IMAGES
of America

POLAND SPRING

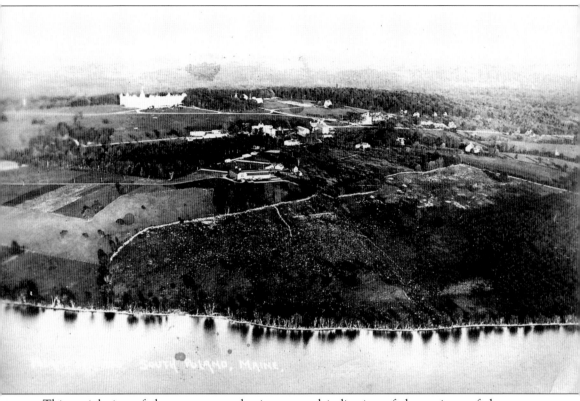

This aerial view of the resort grounds gives a good indication of the entirety of the resort grounds as they were in the 1920s. In less than 150 years, the original Ricker property was greatly expanded to be over 5,000 acres of woodlands, lakeside properties, farm pastures, a golf course, three hotels, and numerous other buildings. (Poland Spring Preservation Society collection.)

On the cover: The Poland Spring House, built in 1876, was the crown jewel of the Poland Spring Resort. Eventually the summer hotel had 500 rooms, an elevator system, gift shops, a barbershop, a bowling alley, dormitories for the help, and many other features and amenities. Rising above the landscape, many locals affectionately referred to the hotel as the "Castle" and were devastated when it was destroyed by fire in 1975. (Poland Spring Preservation Society collection.)

IMAGES
of America

POLAND SPRING

Poland Spring Preservation Society
and Jason C. Libby

ARCADIA
PUBLISHING

Published by Arcadia Publishing
Charleston SC, Chicago IL, Portsmouth NH, San Francisco CA

Printed in the United States of America

Library of Congress Control Number: 2009920829

For all general information contact Arcadia Publishing at:
Telephone 843-853-2070
Fax 843-853-0044
E-mail sales@arcadiapublishing.com
For customer service and orders:
Toll-Free 1-888-313-2665

Visit us on the Internet at www.arcadiapublishing.com

To the travelers who have found hospitality here since 1794,
when strangers knocked on the Rickers' door,
and to the visionaries who preserved its history.

CONTENTS

ACKNOWLEDGMENTS

The Poland Spring Preservation Society would like to thank all the contributors for their generosity in providing information and images contained in this text. The contributors include Sonny Chipman, Maria Delgado, Tudi Feldman, William Guptill, Peter MacDonald. and Nestle Waters North America.

A great deal of thanks goes to board member Cyndi Robbins for her assistance in scanning images, serving as a sounding board for items for inclusion, and contributing materials for the publication. Special thanks also go to board members Linda Goodwin and Bob Joncas and director emeritus Marion Emery for their valuable input and support throughout this project.

Other individuals who provided assistance in the creation of this publication include Lenny Brooks, Liz Dickey, Sue Joncas, and George Ricker. The society would also like to praise David L. Richards, Ph.D., for his book *Poland Spring: A Tale of the Gilded Age, 1860–1900*, which proved to be a superb resource while working on this publication.

The task of researching, writing text, and boiling down the thousands of images in our archives in order to tell the Poland Spring story was a difficult task. There are many stories, memorable events, famous individuals, and unique historical footnotes to mention in giving an account of Poland Spring. In response, the society would like thank Jason C. Libby, executive director of the organization, for presenting this project to the board of directors, coordinating its creation, and compiling the text and images.

Unless otherwise noted, all images appear courtesy of the Poland Spring Preservation Society collection. Images obtained from other collections are noted in the following manner: Sonny Chipman (Chipman collection), Maria Delgado (Delgado collection), Tudi Feldman (Feldman collection), Linda Goodwin (Goodwin collection), William Guptill (Guptill collection), Jason C. Libby (Libby collection), Peter MacDonald (MacDonald collection), Nestle Waters North America (NWNA collection), and Cyndi Robbins (Robbins collection).

INTRODUCTION

The story of Poland Spring begins in 1794 when Jabez Ricker moved his family from Alfred to present-day Poland. Jabez owned land adjacent to the Shaker community in Alfred, and when they pressed him to acquire his land by stating that God wanted them to have it, he relented and made the land swap. Shortly after the family's arrival in Poland, some travelers knocked on the door looking for a place to stay. The family seized upon the opportunity and by 1797 opened the Wentworth Ricker Inn, thus beginning a tradition of operating an inn on the grounds that continues today.

In 1844, Hiram Ricker, after suffering from dyspepsia for many years, went to the fields to oversee the men working on the farm. For several days he drank only water from the spring on the edge of the property, and he was cured of his illness. While this was not the first time members a family drank from the spring and were cured of their ailments, this was the first time someone believed that the water had medicinal properties and was the sole reason for their cure. Hiram began sharing the water with friends and neighbors, and in 1859, he made the first commercial sale of the water. In marketing their inn as a country getaway with recreational activities and having water with health benefits, the Rickers began to drastically grow their enterprise.

In 1876, due to the popularity of the mineral water, the family opened a summer hotel, the Poland Spring House, which quickly became a popular attraction for the country's social and political elite. The hotel eventually consisted of over 500 rooms, a barbershop, a billiard room, a music hall, dining facilities, a fire sprinkler system, and elevators, photography and dance studios, and much more served as the crown jewel of the resort grounds. Its design and offerings were copied and used at the SamOset in Rockland and the Mount Kineo House at Moosehead Lake, which were the other Ricker-operated hotels in the state.

The resort also took an unprecedented step in 1894 when it purchased the Maine State Building. The building, constructed of granite, hardwoods, and slate from Maine, was originally constructed as the state pavilion for the World's Columbian Exposition of 1893 in Chicago. The building was disassembled, transported to Poland Spring, and reassembled for use as a library and art gallery. It remains as one of only a handful of buildings left from the almost 200 that comprised the fair.

In 1896, Poland Spring opened a golf course, one of the first in the state and the first course at a resort in the United States. The Rickers commissioned Arthur H. Fenn to design the course. Fenn, considered by many to be the first American-born professional golfer, stayed on for many years as the golf professional at the resort. In 1912, the resort desired a modernization of the course and contracted with Donald Ross to redesign the course and expand it to 18 holes.

In 1907, Hiram Ricker and Sons Company opened a new bottling plant and springhouse on the property. This was perhaps the most modern bottling facility of its time, installed with glass and silver piping, nonporous Cararra glass for easy cleaning, and even showers for the workers to use prior to beginning their shift. The company had depot offices in major cities throughout the country like Boston, New York, Philadelphia, and Chicago and even had offices overseas in Cairo, London, and elsewhere. Poland Water was served in every corner of the world and was an easily recognizable brand.

The 1930s were not kind years for anyone, including the Ricker family. With the eventual loss of control over their empire due to low occupancy as a result of the Great Depression and the death of the three sons who managed the business within five years, Poland Spring was reorganized and became owned by several businesses. In 1962, Saul Feldman, a hotelier, purchased the resort and built a new inn on the grounds and tried to attract a new clientele by offering modern amenities. In 1966, Feldman leased the buildings on the grounds to the U.S. government for use by the Job Corps program, and Poland Spring became the site of the largest women's training center in the country until its closure in 1969.

In 1972, Mel Robbins came to Poland Spring to develop the 5,000 acres into residential housing and fell in love with the character of the resort. He leased the property from Feldman and Mel and his wife, Cyndi, began the process of rebuilding the historic property. In 1975, the Poland Spring House burned to the ground, but the resort moved forward. In 1982, Mel and Cyndi purchased the resort from Feldman, and it continued on with new life and energy.

Preservation of the historical character and nature of the community has been a goal of the inhabitants of Ricker Hill. The Poland Spring Preservation Society was formed in 1976 to preserve and restore the Maine State Building and the All Souls Chapel, which was built as an interdenominational chapel for the guests and staff of the resort. The Robbins family, owners and operators of the Poland Spring Resort for almost four decades, also see the preservation of the grounds and structures as one of their missions. Nestle Waters North America, which acquired Poland Spring Water, has also made extraordinary efforts in restoring the Ricker-built bottling plant and springhouse to their former glory. These three entities continue to work together to protect landmarks that are not just reminders of the past but also serve to celebrate our successes as a society.

This publication attempts to capture some of the memorable occasions in the history of Poland Spring. While it would be an impossible task to show a picture of every room, mention every event, or note every "first," the book does give the reader an opportunity to look at over 200 years of history and grasp the essence of what has made Poland Spring alluring to visitors throughout the ages.

One

THE RICKERS AND THE OLD HOMESTEAD

The Ricker family of Poland Spring traces its lineage from Maturin Riccar (original spelling of the surname), one of two brothers who came from the Isle of Jersey to Dover, New Hampshire. The coat of arms and their ancestral lineage would become important to them as they marketed their business in the Victorian age. The motto *Sapientia Donum Dei* translates to "Wisdom is the gift of God."

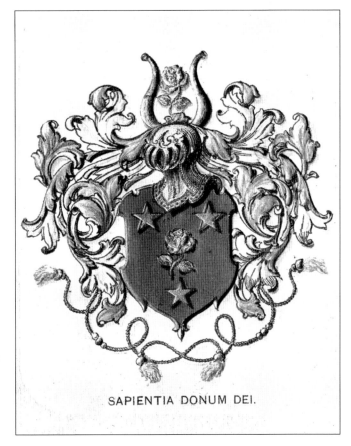

SAPIENTIA DONUM DEI.

Jabez Ricker, grandson of Maturin Riccar, moved his family to Bakerstown, present-day Poland, in 1794 after exchanging land with the neighboring Shaker community in Alfred. The Shaker community wanted their property for the mill rights. According to family lore, within a day or two after traveling nearly 50 miles themselves, two strangers asked to stay at their home and the inn-keeping tradition began.

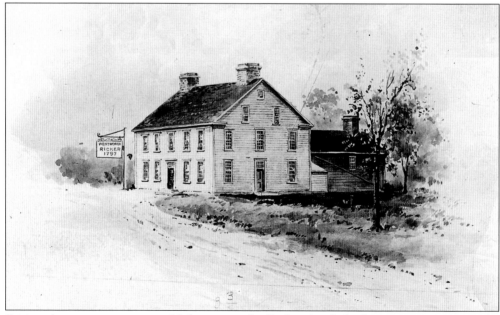

Seizing the opportunity to establish an inn, the Ricker family built a new structure on the grounds, and in 1797, the Wentworth Ricker Inn opened. As it was the home of the Ricker family, the inn was open all year. Some of the first public religious meetings in the community were held in the building.

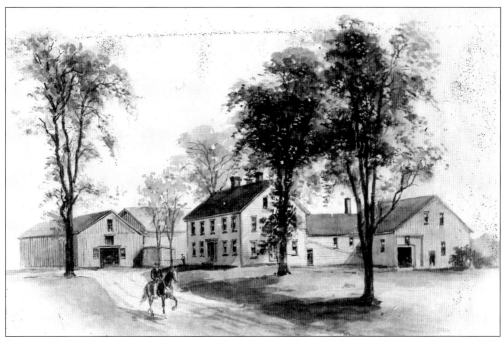

Around 1850, the inn became known as the Mansion House. This was the first drawing of the inn and was sketched by James Harper of Harper and Brothers Publishers. The inn was on the major route between Portland and Montreal, but when the railroad was built nearby in the 1840s, there was a decline in travelers in need of a room.

The timely discovery of the medicinal properties of springwater on the property in 1844 probably saved the inn from failure. The spring played a role in the recuperation of several members of the family before that time but was not given sole credit. For example, in 1800, Wentworth Ricker's brother Joseph lay sick with a fever, was pronounced hopeless, drank freely of the water, and recovered, living another 52 years.

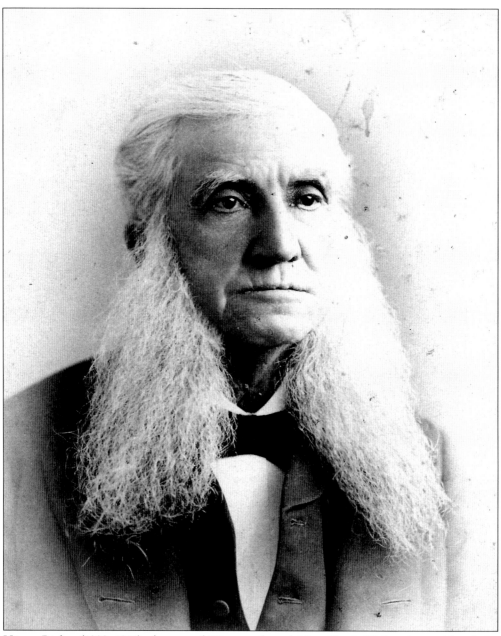

Hiram Ricker (1809–1893), the son of Wentworth and Mary Pottle Ricker, is considered the founder of Poland Spring Water. In 1834, he took over the operations of the Wentworth Ricker Inn from his father after working in Boston. Throughout life he made several business dealings that went sour, including a steamboat operation on the Androscoggin River that on its maiden voyage ran aground and ceased operations. It was not until he began touting the benefits of his springwater that he saw substantial success. In 1844, Hiram was out watching the men work in the fields and due to thirst he began to drink from the spring. After freely drinking the pure cold water, Hiram, who had been affected by dyspepsia for much of his adult life, felt reinvigorated and his affliction cleared. It is at this time he began to proclaim the water's medicinal properties and sought to share it with his neighbors and others.

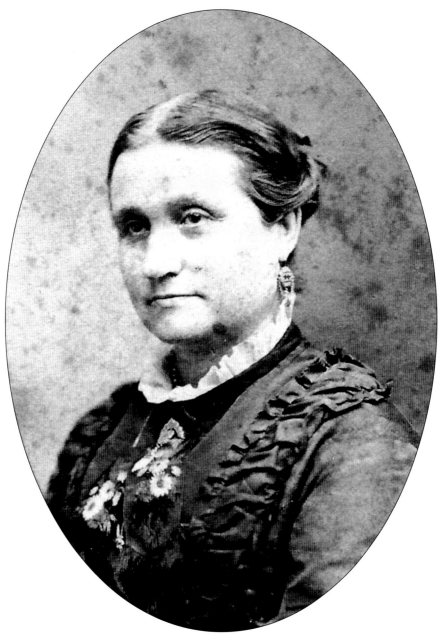

Janette Wheeler Bolster (1821–1883) was the daughter of Alvan Bolster and Cynthia Wheeler Bolster of Rumford. Alvan Bolster was a farmer, member of the Maine State House of Representatives and state senate, and a general of the militia, and Cynthia was a schoolteacher until she and Alvan were married. Janette had studied art in Boston and was certainly the inspiration for her daughter Janette "Nettie" Ricker to become an artist. Resort guests thought very highly of Janette due to her hospitality and her abilities as a hostess, mother, and community member. Janette and Hiram were married in Thompsonville, Connecticut, in 1846 and had six children, all born in the Mansion House except for Alvan Bolster Ricker, who was born in Rumford. It was through her family lineage that their children would claim membership to the Mayflower Society as well as the Daughters of the American Revolution.

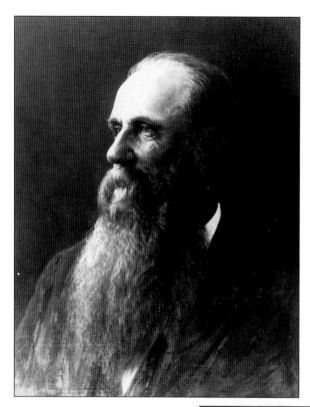

Edward Payson (E. P.) Ricker (1847–1928) took an early interest in inn-keeping and assumed overall management of the company in his 20s. Later in life, as a conservation-minded individual, he was instrumental in seeking regulations on water usage by power companies in order to prevent a negative impact on tourism. He had two children with his wife, Amelia Glancy of Boston.

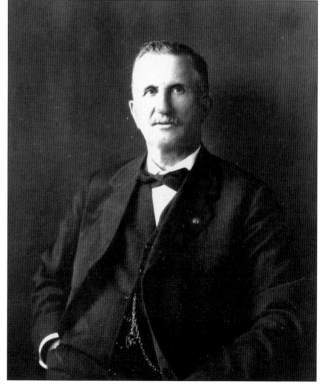

Alvan Bolster (A. B.) Ricker (1850–1933) was more interested in the "back of the shop" operations and was known for his keen memory and sometimes fiery personality. A. B. focused on the resort gardens and all the resort farms, overseeing the kitchens and purchasing goods at market to meet the dining demands of the growing resort. He had three children with his first wife, Cora Sanders of Waldoboro.

Cynthia Ella Ricker (1852–1937) was the oldest daughter and in 1873 married Oliver Marsh and moved to Springfield, Massachusetts, where she had five children Although her involvement with the family business was limited, she did make annual pilgrimages back to Poland Spring with her family and helped lead the procession for the dedication of the Maine State Building in 1895.

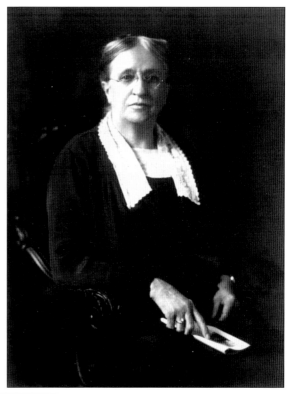

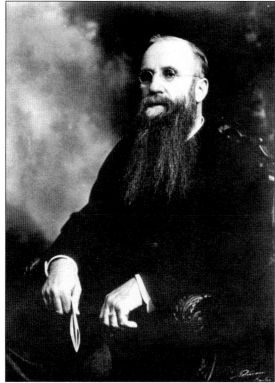

Hiram Weston Ricker (1857–1930) took a great interest in the tourism industry as a whole while maintaining his traditional role in managing the water sector of the business. He was instrumental in creating the Maine Automobile Association and the Maine Publicity Bureau. Hiram was also a life member of the Lewiston-Auburn Rotary Club and, like his brothers, a Freemason. He and his wife Vesta Folsom of Lewiston had three children.

Sarah "Sadie" Ricker (1860–1953) remained unmarried, and her main interest was religious instruction and activities for the children in the community. These interests helped to fuel her quest in overseeing the creation of a Sunday school program and toward the construction of the All Souls Chapel on the resort grounds.

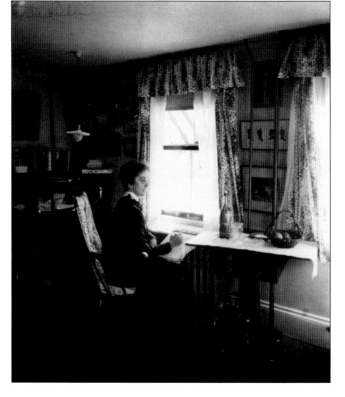

Janette "Nettie" Ricker (1865–1944) was the youngest of Hiram and Janette's children. She aspired to be an artist, taking after her mother, Janette. She served as coeditor of the Hilltop resort weekly newsletter and as the director of the Poland Spring Art Gallery housed in the Maine State Building. One of her greatest personal achievements was being made an associate member of the Boston Art Guild.

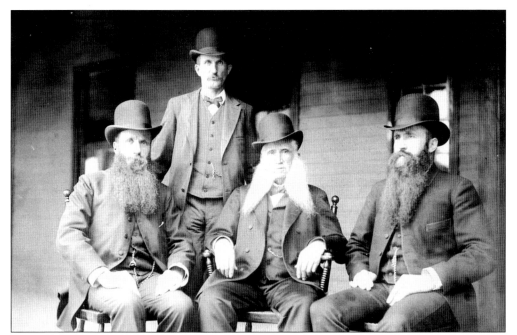

Five of Hiram and Janette's six children would remain on the grounds and take part in the family business, but as a reflection of the times, the sons were much more involved in the operations of the resort. From left to right are E. P. Ricker, A. B. Ricker, Hiram Ricker, and Hiram Weston Ricker.

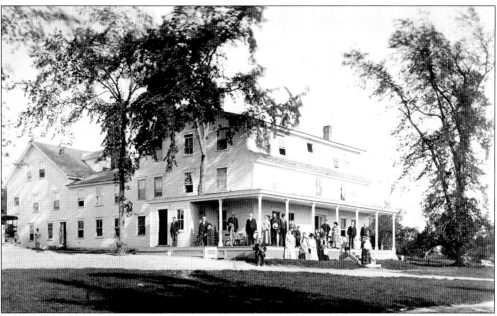

In the early days of the Mansion House, it was more like a country inn with opportunities for outside recreation and "taking of the waters." As business increased, the resort needed to keep up with the demands of its new clientele, which spurred the building of the Poland Spring House. The Mansion House seen here in 1875 also needed to be expanded and would see several enlargements over the next decade.

The family, whether it was due to their sense of humor, for necessity, or for fondness for this tree, built the porch and porch roof around it instead of cutting it down to make way for enlargements. The rather unique feature would continue to be part of the fabric of the old homestead for much of the life of the building.

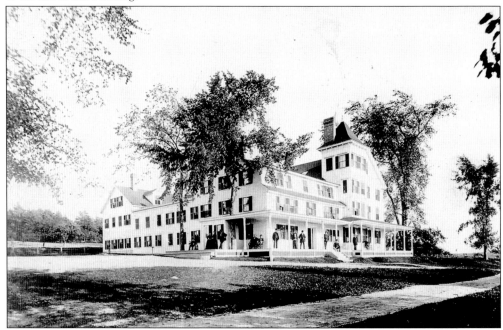

In 1883, the front facade was altered to give the Mansion House its distinctive tower. The building would undergo several renovations in the next three decades, including the replacement of gas with electricity in 1898, the new wing addition in 1905–1906, and the bath department in 1914. The older portion of the Mansion House would remain relatively unchanged.

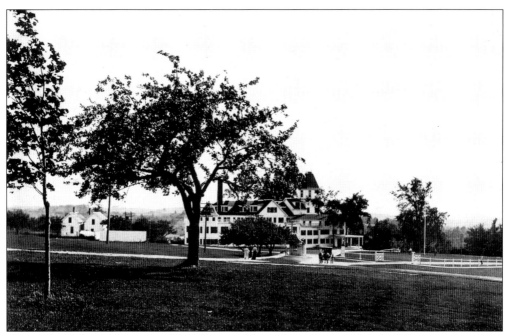

This early-20th-century view of the Mansion House from the top of the hill shows two cottages that were built behind the building for laundry and to house employees. Cottages like these and several old farmhouses along the main road were bought by the resort and used to accommodate employees as the business grew.

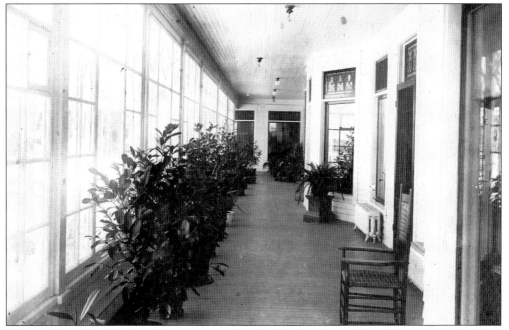

The porches of the Mansion House were enclosed with glass during the colder season and offered visitors as well as houseplants a place to get some needed sunlight. The picturesque view lent itself to the winter landscape at the homestead, which also served as a quiet solace for those unwilling to brave the elements.

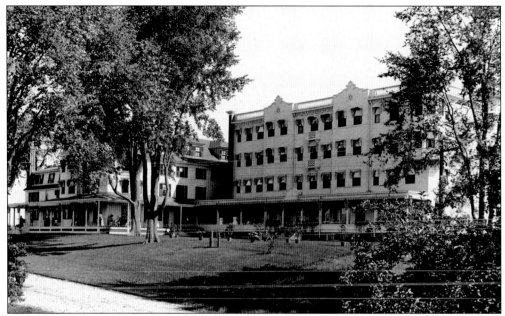

The last major addition to the Mansion House was the "new wing," which was added in 1905–1906. The wing contained a new dining room and elevator service, and all the rooms above the first floor had outside views to the east, south, and west. When the addition was completed, a new modern kitchen and laundry facility were also completed that ensured the maximum of safety and minimum of noise.

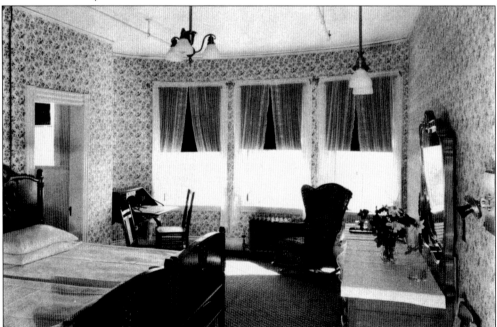

A typical bedroom at the Mansion House was complemented by quality furnishings and eventually electric lights and steam heat. In the early days, there were no private bathrooms, and even in later years guests would continue to share common bathrooms. When the new wing was completed, private bathrooms were added to almost every room.

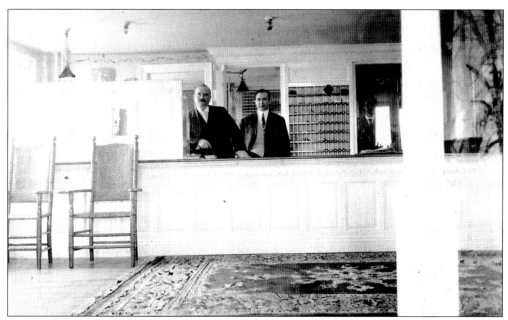

Personnel wait in the Mansion House office to serve another guest. Rates at the hotel fluctuated according to the season. During the 1880s–1890s, rates at the Mansion House were between $8 and $15 per week. In comparison, the rates at the Poland Spring House during the same period were between $10 and $17.50 per week. Other more expensive suites and apartments were also available on the grounds

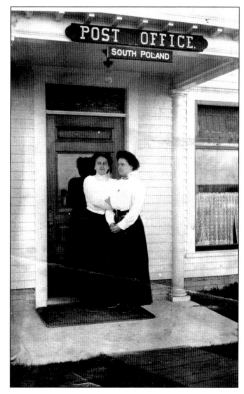

This post office that served South Poland was housed out of the Mansion House offices. In the spring of 1909, the post office was relocated to the rear of the building in order to make more room for the inn's office. From 1870 to 1900, either Hiram Ricker or his son Hiram Weston Ricker served as postmaster.

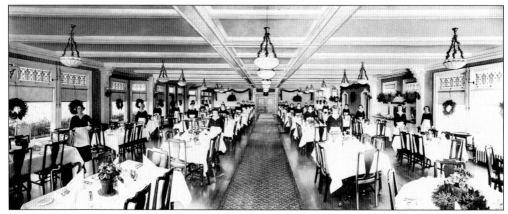

The Rickers were very customer service minded, and it shows through the way in which they fed their guests. In this picture of the Mansion House dining room, each table has its own waitress, and there were also side hall waitresses and several waiters on hand. For example, in 1900, there were over 120 waiters and waitresses on staff between the two hotels.

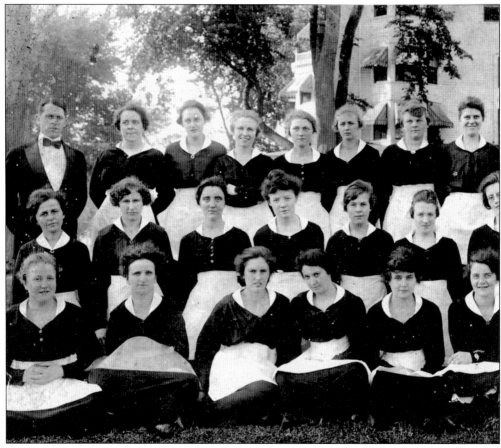

Many of the waitresses that staffed the tables in the late 19th and early 20th centuries were brought from Boston and surrounding communities and were paid relatively well for their work. A waitress working in the dining halls in the 1890s for example was paid $2.50 each week with room and board provided by the resort.

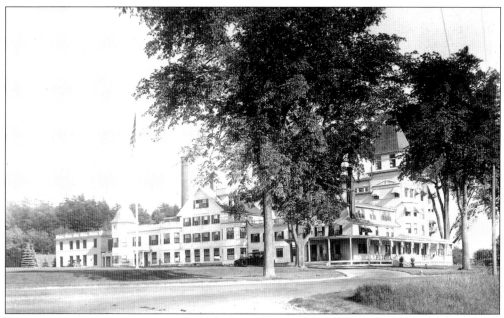

To continue to attract new guests, the bath department was added in 1914 and offered therapeutic baths, massages, electrotherapy, and other hydropathic treatments. In marketing the new services it was clear that the resort was not a sanitarium but that it had a desire to build on its reputation as a place for those desirous of rest, pleasure, and health. The department can be seen at the far left.

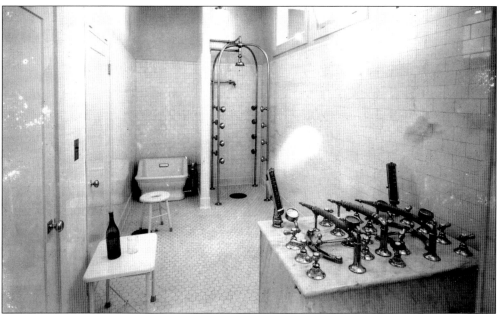

When the bath department was opened, the resort wanted to benchmark its innovations with those of European hotels. It hired several doctors and nurses to consult with guests and to prescribe them with the best treatments for their ailments. Of course it is almost assured that every regimen for their guests included drinking plenty of Poland Water during their stay and afterward.

After A. B.'s first wife, Cora, died in 1922, he married Jane Jeffrey (1880–1960), who came to work in the bath department. She served in World War I and was struck in the back with a large piece of shrapnel. For her heroism, she was awarded the Distinguished Service Cross and Legion of Honor. At the time she was one of only four women to receive the Distinguished Service Cross.

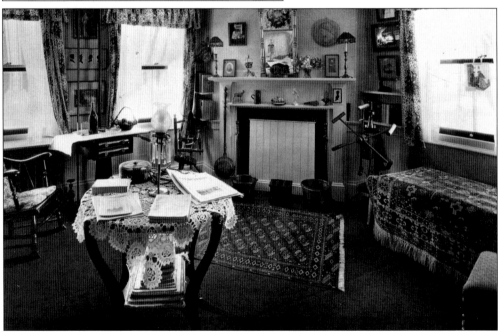

Even though some of the members of the Ricker family left or built other houses on or near the grounds, Sadie and Nettie continued to live in the old homestead. This picture is of Nettie's room in the early 1900s. Nettie's and Sadie's rooms were on the second floor of the house just above the entrance to the office.

Two

The Grand Hotels

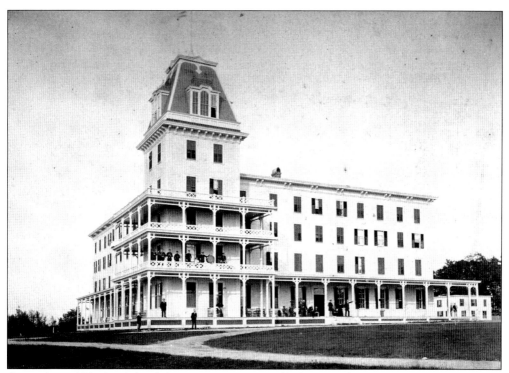

Opened in 1876, the Poland Spring House eventually became the crown jewel of the resort. When it was first constructed, it might have been described as an elegant farm building rather than the grandiose hotel that it would become. Hiram Ricker took on Albert Young of Auburn as a partner in the construction of the building. Within a decade, Young would be bought out by the Rickers.

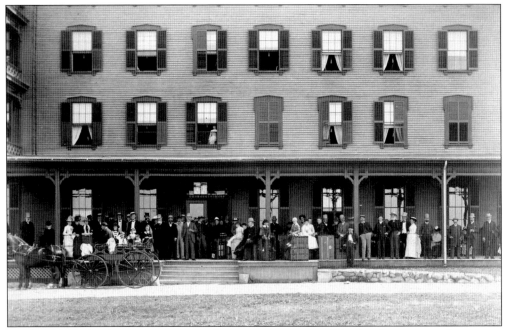

Until automobiles became more prevalent, most guests would take the train and arrive at Danville Junction, which was about seven miles from the resort. In the early days, a Poland Spring carriage was sent to the station to pick up visitors. Here guests wait for the wagon to pick them up at the Poland Spring House to take them back to the train station.

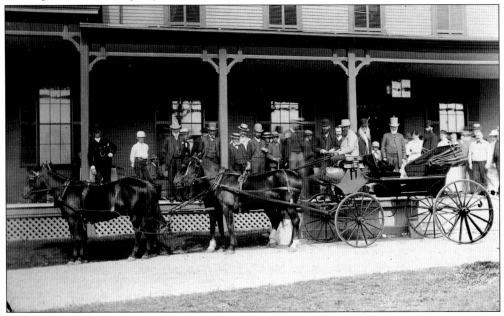

The summertime attracted a number of political and social leaders like James G. Blaine (standing behind the carriage with a white beard) at the Poland Spring House during his presidential campaign in 1884. Other notable individuals from this era who visited the resort include Pres. Grover Cleveland, Civil War generals Oliver O. Howard and Benjamin Butler, Frederick Douglass, Booker T. Washington, and many others.

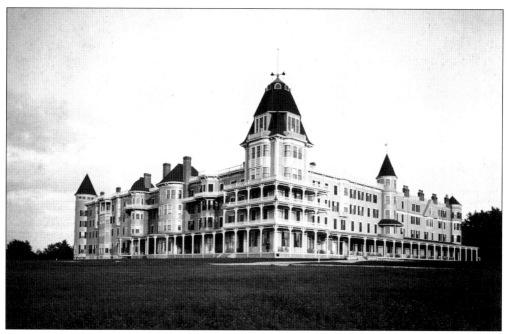

The series of renovations at the Poland Spring House in the late 19th century lengthened the wings on both sides of the building and added several towers. Several other buildings were constructed that were not part of the larger hotel structure and added to the complex in order to satisfy the needs of the growing hotel clientele.

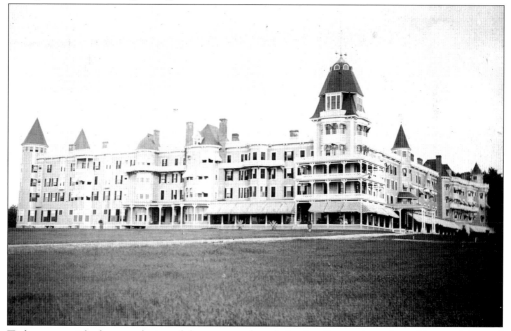

To keep up with the popularity of the summer hotel, the family continued to add amenities and increase the number of guest rooms. By 1893, the summer hotel had an enlarged dining facility, a music hall, a store, covered walkways, a porte cochere at the main entrance, remodeled offices, and a foyer and even began to offer therapeutic massages.

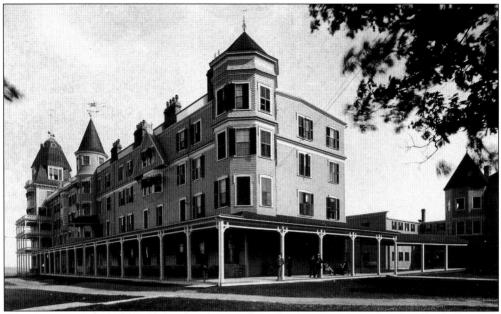

This is a view of the west wing of the Poland Spring House. To the far right is the annex built in 1887, which housed a game room for billiards and the like, a barbershop, and even a gentlemen's lounge. Upstairs several expensive and certainly exclusive apartments were constructed that were many times more expensive than the regular rooms found throughout the hotel.

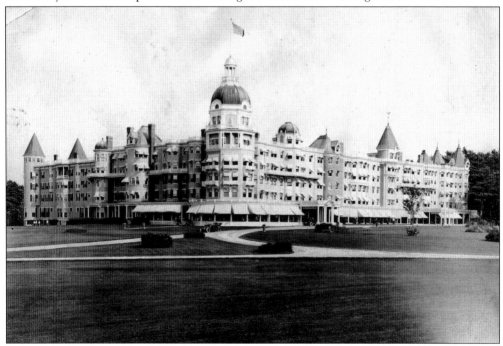

By 1903, the Poland Spring House had almost 500 rooms, a fire sprinkler system, an elevator, and other modern amenities. The distinctive main tower, which had been altered several times from the original construction in 1876, was once again redesigned and built with eight symmetrical sides of copper under a dome of gold leaf held by eight Corinthian columns.

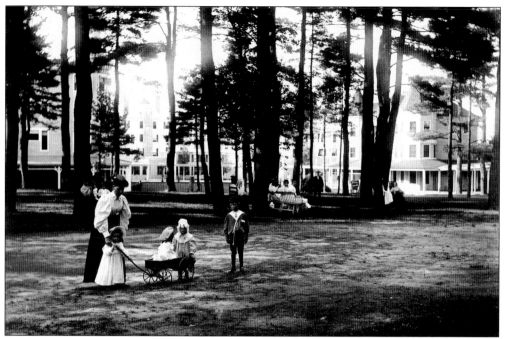

For children and their nannies, the grove was a popular spot. Here the children could play and be out of sight while their parents relaxed, socialized, or played. In later years a children's clubhouse would be built as well as a children's camp on the back side of the property behind Hiram Weston Ricker's cottage.

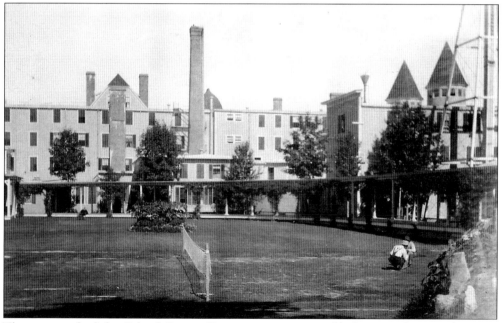

The courtyard of the Poland Spring House was a very suitable location for special events, picnicking, lawn parties and fetes, reading, conversation, outside musical acts, or for people or animal watching. Recreational sports like badminton, croquet, and the like were also popular in this section of the Poland Spring House complex.

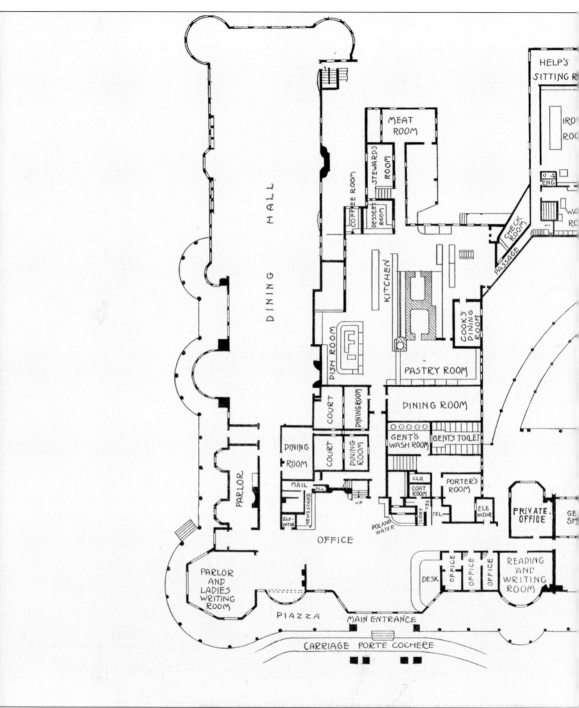

This plan of the main floor of the Poland Spring House shows the footprint of the structure by the 1920s. Four floors of guest rooms followed a similar imprint with fifth floors in each of the towers. Above the ironing room and help dining room facility, there were two floors of living space for employees of the summer hotel. There were also two floors of plush and private apartments above the game rooms and barbershops of the annex. Not shown in this plan are

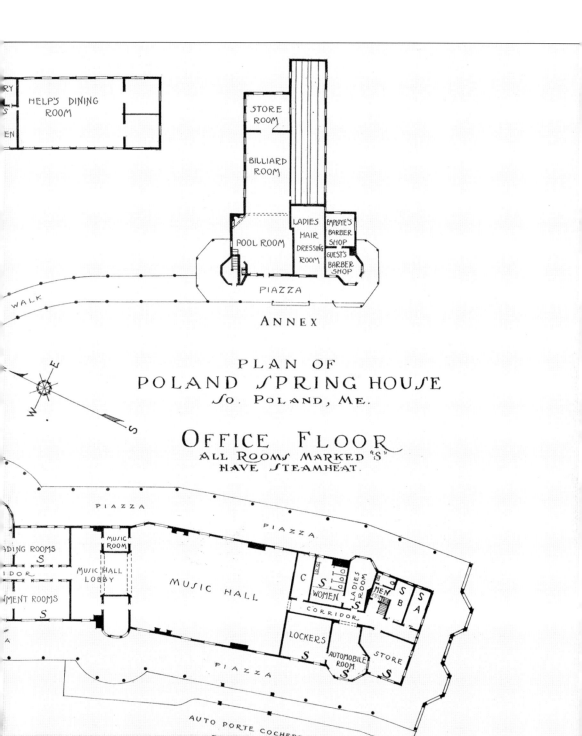

HELP'S DINING ROOM

STORE ROOM

BILLIARD ROOM

LADIES HAIR DRESSING ROOM

EMPLOYE'S BARBER SHOP

GUEST'S BARBER SHOP

POOL ROOM

PIAZZA

ANNEX

WALK

PLAN OF
POLAND SPRING HOUSE
So. POLAND, ME.

OFFICE FLOOR
ALL ROOMS MARKED "S"
HAVE STEAMHEAT.

PIAZZA

PIAZZA

DING ROOMS

S

MUSIC ROOM

MUSIC HALL LOBBY

IDOR

MENT ROOMS

S

A

MUSIC HALL

C

S

WOMEN

LADIES ROOM

MEN

S

B

S

A

S

CORRIDOR

LOCKERS

S

AUTOMOBILE ROOM

S

STORE

S

PIAZZA

AUTO PORTE COCHERE

several separate buildings that were built for carpenter shops, lumber storage, a power plant, and boiler rooms, as well as an art studio that was used by Nettie Ricker. The 19th hole and golf professional office was underneath the dining hall along with a series of tunnels built for utilities and some storage space.

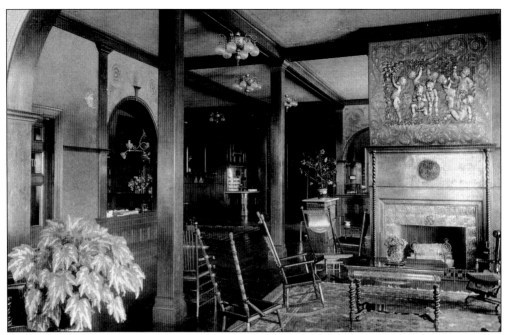

This 1894 view of the Poland Spring House offices and sitting area reveals the fine craftsmanship and exquisite décor. Remodeled in 1886, at the far left is the door to the elevator, next to it is the newsstand, the Poland Water counter is at the center, and the front desk can be seen peaking out from behind the fireplace. Guests would enter from a doorway just behind the fireplace.

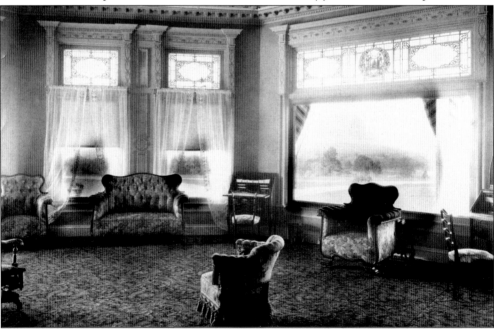

The ladies' writing room and parlor were a palatial section of the hotel because of its command of the grounds. Located on the main level of the tower, the room's original purpose was to serve as a place for women to socialize and write letters and read. Beautiful windows along with a stained-glass representation of the Maine state seal line the room.

Water sales helped to finance the construction of the building in 1876 even though the country was in the midst of a depression. Poland Water, as the cornerstone of the resort's reputation, would always have a place of prominence in the lobby of the hotel. As the grounds were dry until after Prohibition, water was served at this counter instead of alcohol.

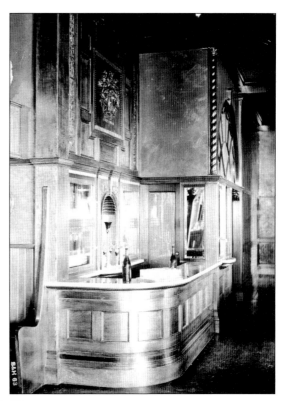

A photography studio under the management of the Notman Photographic Company of Newton, Massachusetts, was added to the Poland Spring House in 1894. Here guests and many Ricker family members would have their portraits taken. The studio also offered for purchase photographs of local scenery, life on the grounds, and buildings at the resort.

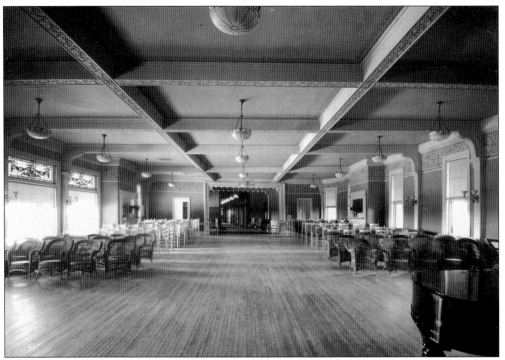

The grand music hall in the Poland Spring House was used for many different events throughout the years. Religious services, led by headwaiter Julius Gassauer, were held here until the chapel was built, but the hall normally held musical recitals, lectures, and other performances for the pleasure of the resort guests.

Daniel Kuntz, pictured here on Middle Range Pond, led one of the early orchestras composed of several members of the Boston Symphony Orchestra. Normally playing in the music hall, the Kuntz-led orchestra also played at many of the prominent events on the grounds including the Maine State Building dedication in 1895 and the dedication of the All Souls Chapel in 1912.

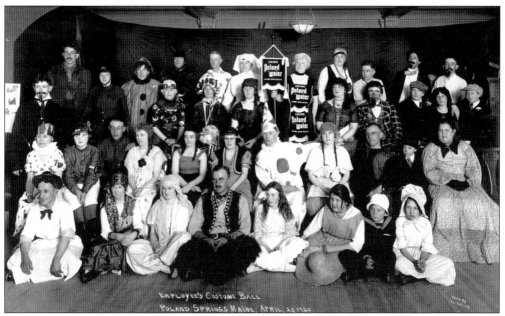

Many balls and dances were held in the Poland Spring House during the summertime. Here staff and members of the family gather in 1920 for a picture at an annual employees' masquerade ball. Many of these galas held for guests at the Poland Spring House helped to raise funds for special projects like the construction of the chapel and to support the Poland Spring "free bed" at the hospital in Lewiston.

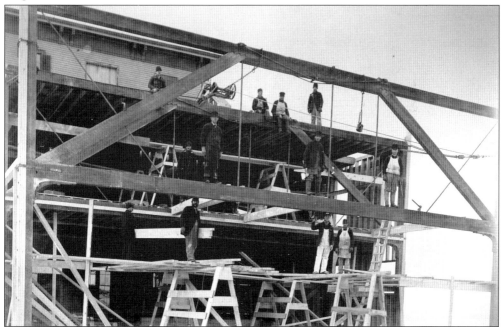

These workers are building an addition to the left wing, which added into the dining room of the Poland Spring House in 1889. John Calvin Stevens, George M. Coombs, and Harry C. Wilkinson were three of the prominent Maine architects to design variations renovations at the Poland Spring House as well as other buildings on the grounds.

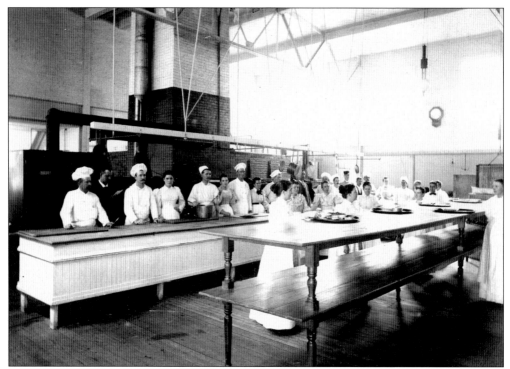

According to the *Hill-Top* resort newsletter in 1909, the kitchen prepared and served on average 3,335 pounds of beef, 2,800 pounds of chicken, 1,875 pounds of fresh fish and lobsters, 400 pounds of bacon, 5,640 ears of corn, 9½ barrels of sugar, and over 3,800 quarts of milk each week.

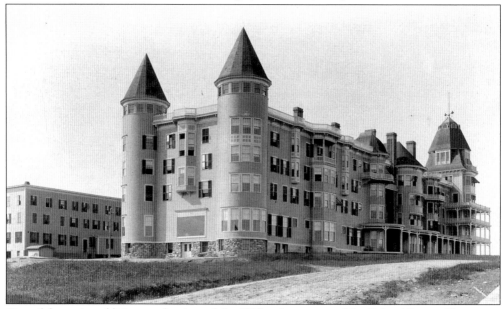

One of the major additions at the time of the 1889 enlargement of the Poland Spring House was an 8-by-14-foot plate glass window. The window, believed to be the largest one installed in the state at that time, offered breathtaking views of the resort grounds and was a focal point of the diners in the dining room.

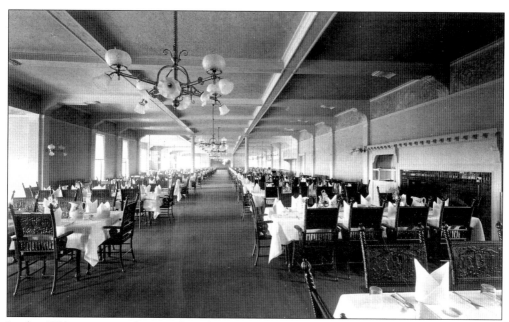

In the 1880s, it was made very clear that there were certain places for servants and children, and the menus from this time period reflect this. A menu from 1884 instructed that guests were invited for breakfast from 7:00 a.m. to 9:00 a.m., dinner from 1:00 p.m. to 2:30 p.m., and tea from 6:00 p.m. to 8:00 p.m. while servants and children were scheduled for times before, afterward, or shortly before the departure of the guests.

Although this picture is absent of color, beautiful hand-painted menu covers like this were created daily by Nettie Ricker. The resort had lavish meals each day and offered a variety of dishes like green turtle a l'anglaise, corned ox tongue, boiled Philadelphia capon, broiled squab on toast, English plum pudding, and Bavarian blanc mange.

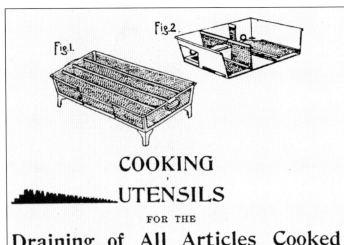

COOKING

▄▃▂▁━━━━━━━UTENSILS

FOR THE

Draining of All Articles Cooked in Deep or Boiling Fat.

DOUGHNUTS, FISH-BALLS, CRULLERS, CROQUETTES, AND FRITTERS FRIED IN BATTER.

ELLA WHEELER RICKER MARSH,

PATENTEE,

145 Spring Street, Springfield, Mass., or Poland Spring.

Cynthia Ricker Marsh used the resort as an opportunity to market a kitchen device she invented. The fryer reduced the amount of grease in foods, and she demonstrated it to guests in the dining room of the Poland Spring House. This advertisement for Cynthia's (listed by her middle name as Ella Wheeler Ricker Marsh) innovation was printed in one of the weekly *Hill-Top* newsletters in 1895.

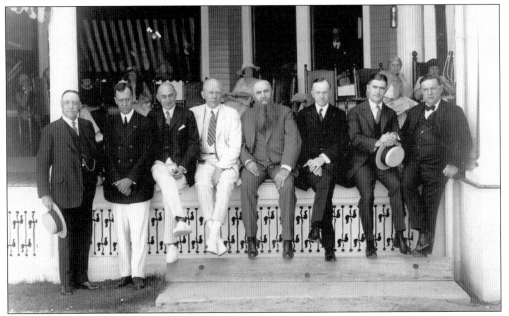

In 1923, the governors of each of the New England states participated in a conference held at the Poland Spring House. Pictured from left to right are good friend of the family and United States senator Bert Fernald of Poland, Gov. Redfield Proctor Jr. of Vermont, Gov. Channing H. Cox of Massachusetts, Gov. Percival P. Baxter of Maine, Hiram Weston Ricker, Vice Pres. Calvin Coolidge, Gov. William S. Flynn of Rhode Island, and Gov. Charles A. Templeton of Connecticut.

The original purpose of the Riccar Inn, built in 1913, was to house the servants of resort guests. The ownership would deny this claim, although the first guest was Robert Maguire of Philadelphia, a chauffeur. In 1981, the building was remodeled and renamed as the Presidential Inn. The building was the last of the three original inns built on the property and the only one that still stands.

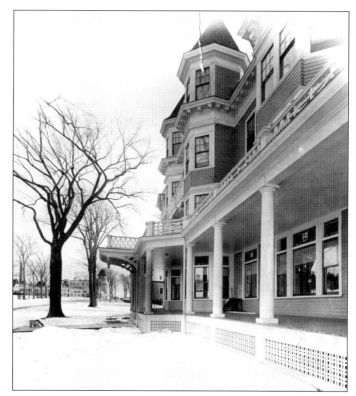

Lobby, Riccar Inn, Poland Spring, Maine,

The ownership maintained that although the Riccar Inn was near a set of stables, the guest garages, and an employee dormitory that it was not deficient. The inn had billiards tables, dining facilities, and reading and sitting areas and shared many of the other amenities afforded to guests at the other hotels on the grounds.

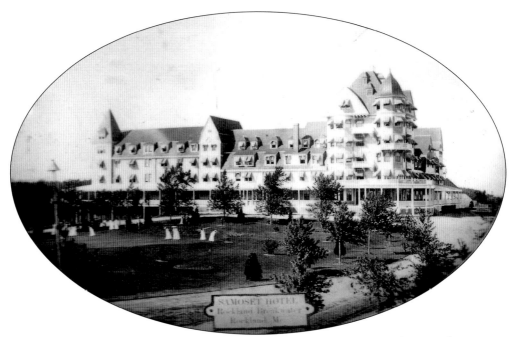

Originally opened in Rockland as the Bay Point Hotel in 1889, the Ricker Hotel Company purchased the property in 1902 and renamed it the SamOset. Before opening the coastal summer hotel, the Rickers had the building renovated with elements, especially its layout and its main tower, which resembled that of the Poland Spring House.

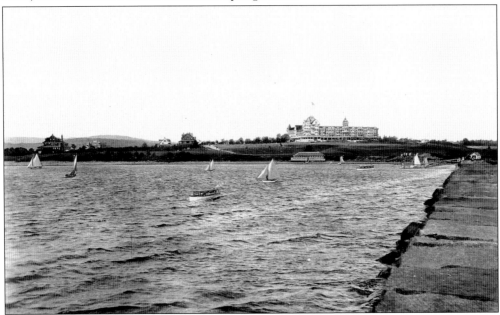

The SamOset offered a great deal of amenities like boating, complimentary touring cars, and a golf course. The links were originally managed by Harris Fenn, the young son of the Poland Spring golf professional Arthur Fenn. The SamOset was sold to Maine Central Railroad in 1911 but remained under the management of the Ricker Hotel Company for several years. The original hotel was destroyed by fire in 1972.

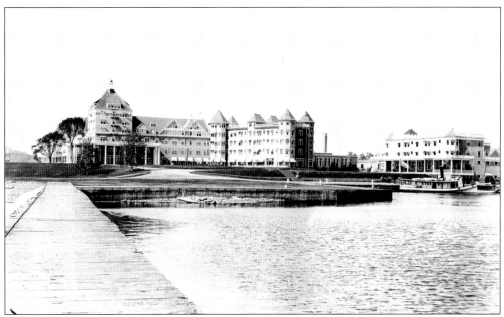

The Mount Kineo House on the edge of Moosehead Lake was originally built as a modest tavern in 1844. It was destroyed by fire and rebuilt several times during the 19th century and was purchased by Maine Central Railroad and was under the management of the Ricker Hotel Company in 1911. Like its cousins at Poland Spring and Rockland, Mount Kineo also offered golf, boating, and other recreational activities and amenities.

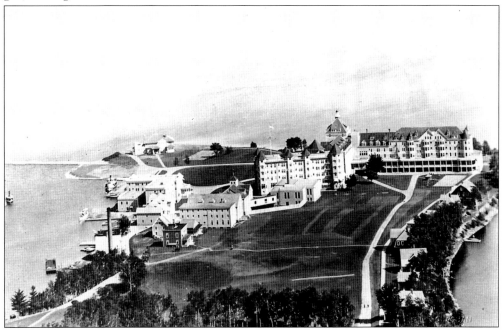

Under the shadow of Kineo Mountain, the hotel was billed as the largest inland resort on the water in the country in advertisements in the early 20th century. The Ricker Hotel Company due to the partnership with Maine Central Railroad was able to draw large numbers of guests to this normally out-of-the-way spot.

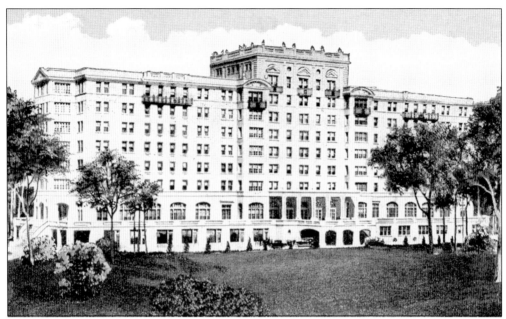

The Forrest Hills Ricker was opened on January 1, 1927, in Augusta, Georgia, and was operated by the Ricker Hotel Company. An 18-hole golf course, also designed by Donald Ross, was laid out on the grounds and was where Bobby Jones captured the Southeastern Open on his way to his grand slam in 1930. The golf course remains, but the hotel is no longer standing. (Goodwin collection.)

The staff of the Poland Spring House would move to Georgia to work at the Forrest Hills Ricker in the winter and return to Maine for the summer season. Even members of the Ricker family involved in managing the business would as well. Here George A. Ricker Jr., grandson of A. B. Ricker and son of George A. Ricker Sr., is seen riding a horse on the grounds of the hotel.

Three

Hiram Ricker's Spring

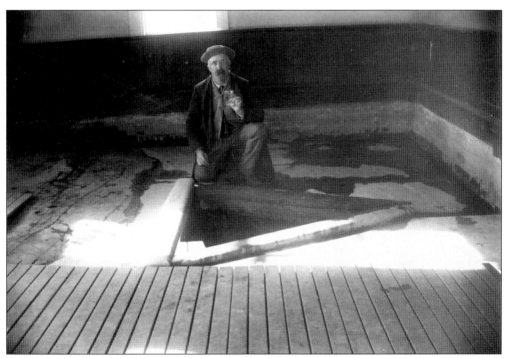

This unidentified man poses with a glass of water fresh from the spring. After Hiram Ricker's proclamation that the water had medicinal properties, he began to share the water with neighbors and friends. Dr. Eliphalet Clark of Portland was the first to analyze the water and begin to prescribe the water for ailments like kidney and liver disease.

In 1859, the first commercial sales of the water began, and it was sold in demijohns, which were clay jugs, for 15¢ each. In 1860, the first advertisement for Poland Water appeared, which cited the medicinal properties, encouraged interested parties to visit the spring, and offered prices for boarding on the property for between $2.50 and $3.50 each week.

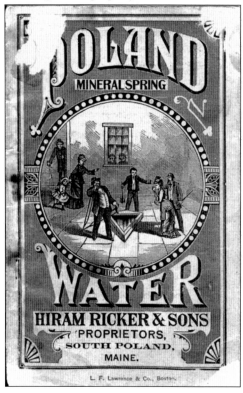

As more doctors began to prescribe the water, Hiram Ricker began to market the water throughout the Northeast. Included in pamphlets like this one from the 1870s was the chemical analysis of the water, names and testimonials of individuals and doctors in major urban areas, and directions for properly tapping a barrel and the manner in which to take the waters. (NWNA collection.)

Poland Water was not only bottled in demijohns but also in large barrels more suitable for long-distance shipping. This springhouse with the barreling house, seen here in 1880, which replaced a rustic wooden structure built in 1860, was expanded many times over the course of the next several decades.

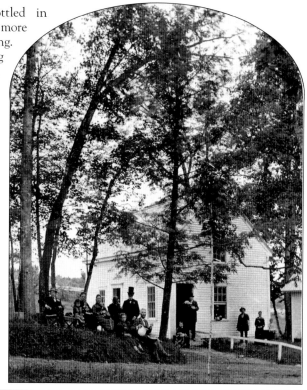

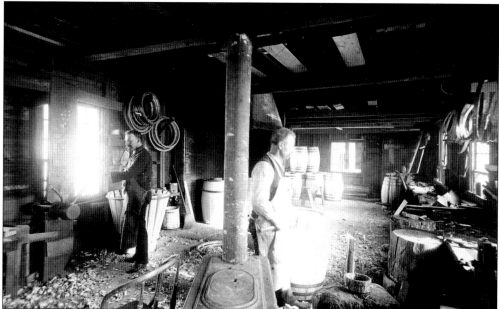

This picture, taken during the winter of 1885–1886, shows two men manufacturing barrels for the shipment of Poland Water. As water sales increased, the Rickers barreled their water to ship on trains to Boston, New York, and beyond. Sales of water had declined during the Civil War and several years immediately following, but upward of 600 barrels per year were sold by the end of the decade.

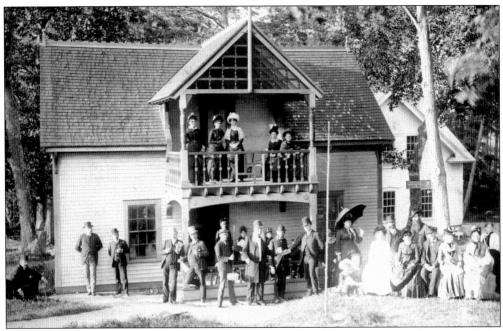

The Rickers added a porch to the springhouse as it became an attraction for their guests. Allowing the public to view the bottling process was one of the foundations of the Rickers' water enterprise and would continue as they expanded their operations. Here Hiram Ricker in the center passes a glass of water directly from the spring to an unidentified guest.

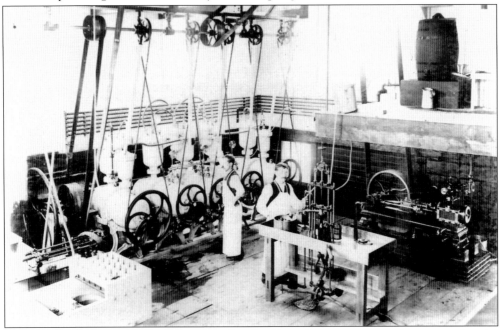

This view of the sterilizing room in the bottling building shows one step in the process that the Rickers took to ensure that the water would be delivered to the customer in its purest form. The bottles would be washed in the bottle-washing room and then sent to the sterilizing room, then to an inspection room, and then packed for shipment.

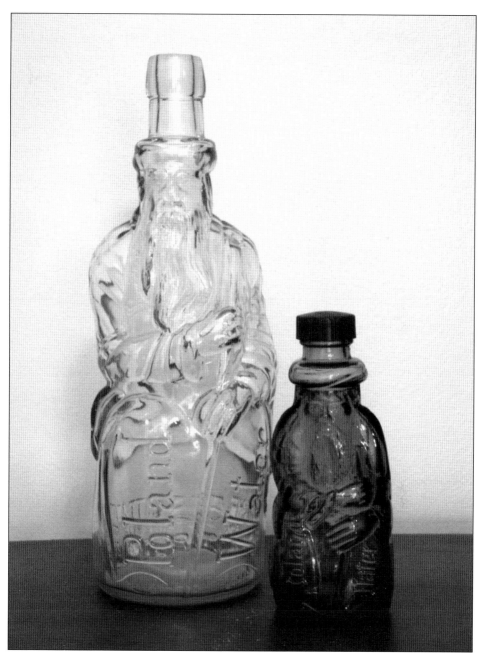

Originally created for the opening of the Poland Spring House in 1876, the Moses bottle became emblematic of Poland Water for generations. Over 40 varieties of the bottles were created, and among the most prized are the original 1876 version and the Honeymoon bottle given to newlyweds staying at the Poland Spring House. The design was meant to depict the biblical story where the prophet Moses struck a stone and water sprang from it—a clear allusion to the Rickers' own bedrock spring. In 1969, an avid collector of Moses bottles, Madelyn "Pal" Vincent, wrote a book about the bottle, its history, and an inventory of all the produced versions. The image was so popular that it even spurned a mystery novel of the same name and was used on the cover. The last official version of the Moses bottle was produced in 1972. (Robbins collection.)

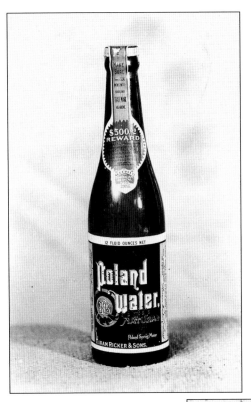

Each bottle of Poland Water had a label to inform customers that there was a $500 reward for evidence that secured the conviction of any person for refilling one of the famous green bottles or selling water under the name of Poland Water not bottled by Hiram Ricker and Sons.

Home delivery was a staple of the business even in the early years. As bottles began to overtake barrel production and consumption, it became a common sight to see wagons carrying water around the town, traveling north to Lewiston and Auburn, south to Portland, or to the train station at Danville.

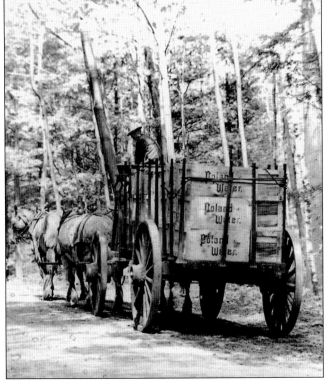

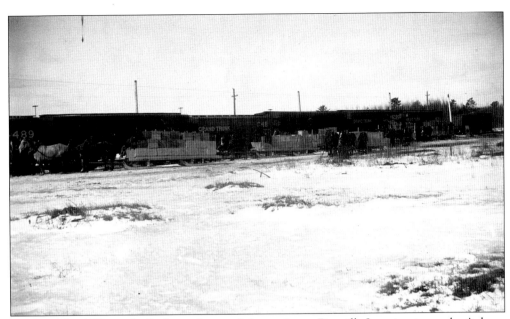

To ship Poland Water, the Rickers often used the station at Danville Junction in nearby Auburn as their loading station. Later after the dawn of the 20th century, the Rickers had a spur line built to connect with the railroad. As a result they owned or operated at least two locomotives. One of these is now at Steamtown National Historic Park in Scranton, Pennsylvania.

One of the first major successes of Poland Water was the collection of an award at the World's Columbian Exposition in Chicago in 1893. The water was recognized for having great purity and as water with health benefits. It served as another reason for the purchase of the Maine State Building as a symbol of their achievement. This is the Poland Water booth at the exposition.

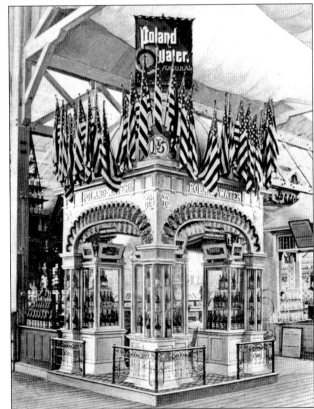

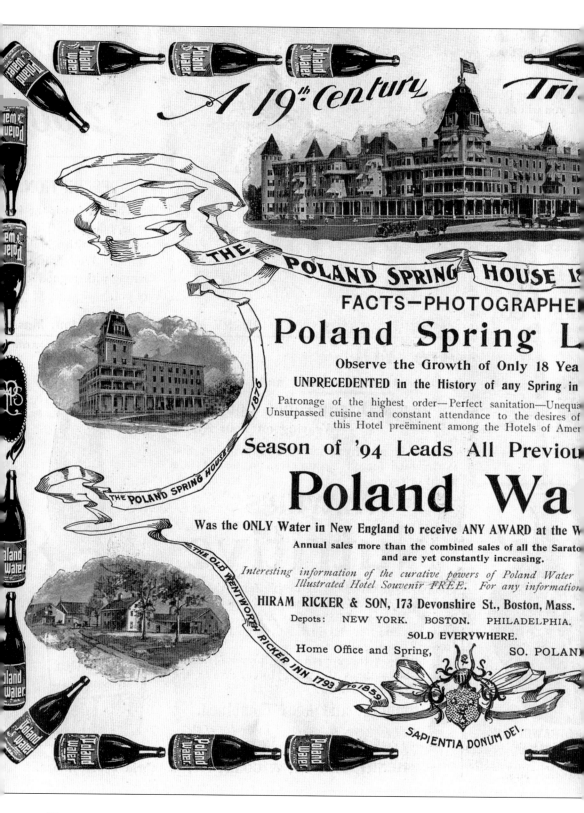

A 19ᵗʰ Century Tri

THE POLAND SPRING HOUSE 18

FACTS—PHOTOGRAPHE

Poland Spring L

Observe the Growth of Only 18 Yea

UNPRECEDENTED in the History of any Spring in

Patronage of the highest order—Perfect sanitation—Unequa
Unsurpassed cuisine and constant attendance to the desires of
this Hotel preëminent among the Hotels of Amer

Season of '94 Leads All Previou

Poland Wa

Was the ONLY Water in New England to receive ANY AWARD at the W

Annual sales more than the combined sales of all the Sarato
and are yet constantly increasing.

Interesting information of the curative powers of Poland Water
Illustrated Hotel Souvenir FREE. For any information

HIRAM RICKER & SON, 173 Devonshire St., Boston, Mass.

Depots: NEW YORK. BOSTON. PHILADELPHIA.

SOLD EVERYWHERE.

Home Office and Spring, SO. POLAN

1876

THE POLAND SPRING HOUSE

THE OLD WENTWORTH RICKER INN 1793 to 1859

SAPIENTIA DONUM DEI.

50

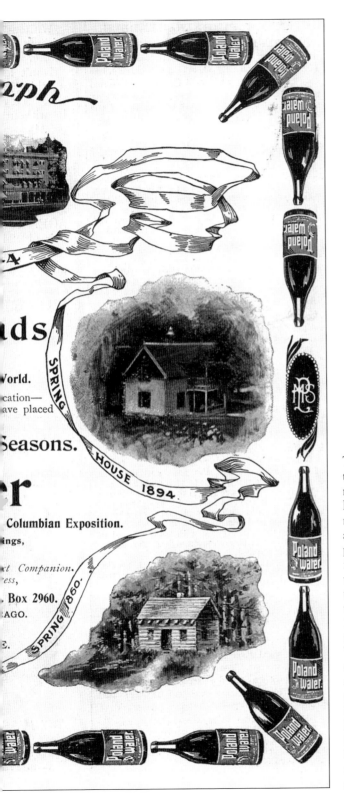

This advertisement came out after the 1894 season and used the medal received at the World's Columbian Exposition as a cornerstone of their marketing, which was augmented after the water received the grand prize at the St. Louis exposition in 1904 "besting the waters of the world." One standard the company used was the comparison of sales with the Saratoga waters. From the 1890s and well into the 20th century, they were far ahead of their New York competitors and made up well over half of the water sales in the state of Maine. The advertisement also depicts, clockwise from the bottom left, the Wentworth Ricker Inn in its early years, the Poland Spring House in 1876, the Poland Spring House in the mid-1890s, the springhouse in 1894, and the springhouse in 1860.

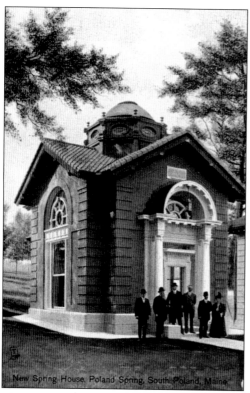

New Spring House, Poland Spring, South Poland, Maine

This springhouse completed in 1907 was built to replace the series of wooden buildings that had covered the spring since 1860. The building was constructed of Italian marble and materials that were common to Spanish and California mission–style architecture. The design, definitely a departure from the past, was of high quality and projected an image of elegance.

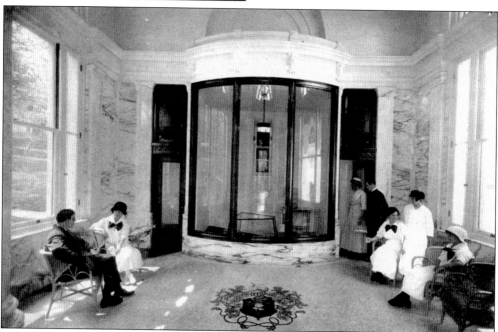

Guests could enter the springhouse as they had in the past and have a glass of water served to them. The interior of the building lent itself to a shrinelike observance of the water where individuals could sit and take the waters, meditate, or even converse with one another instead of remaining outside.

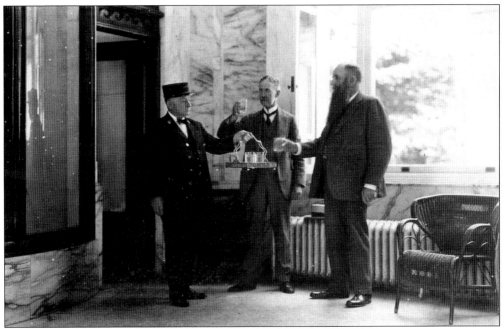

Here spring waiter Edward Jackson serves a guest and E. P. Ricker a glass of springwater directly from the source within the springhouse. It was said that the spring attendants were perhaps the most well-known individuals on the property as they had contact with more guests than any other staff members.

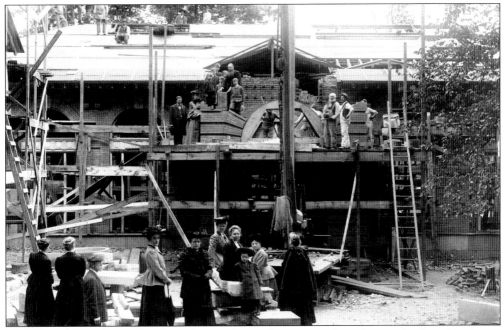

With the advent of a new bottling plant and springhouse to replace the wooden barreling house that had been expanded over the years came opportunities for reflection on the Rickers' success as a family. Here several members of the Ricker family can be seen observing the construction and posing for the camera.

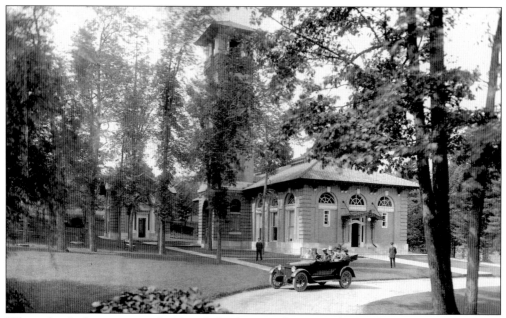

When the facility was completed, it helped to revolutionize the bottling industry. It served as the preeminent model for bottling facilities due to its high-quality construction materials and detailed care to ensure the highest hygiene. Harry C. Wilkinson, who had taken part in designing several of the expansions on the Poland Spring House hotel, drew upon Spanish architecture for his vision.

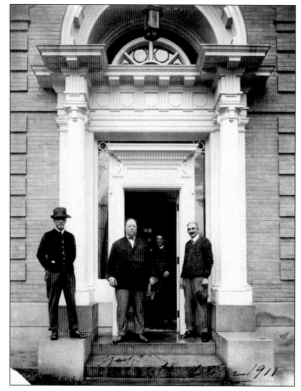

Individuals staying at the resort, whether celebrities like Pres. William H. Taft, shown here in 1912, or the average guest, would certainly peruse the springhouse and bottling facility as they had been for decades. Visitors could enter the bottling factory through an entrance next to the springhouse, walk through a glass-sealed walkway, and sit in the viewing room to watch workers bottle the water.

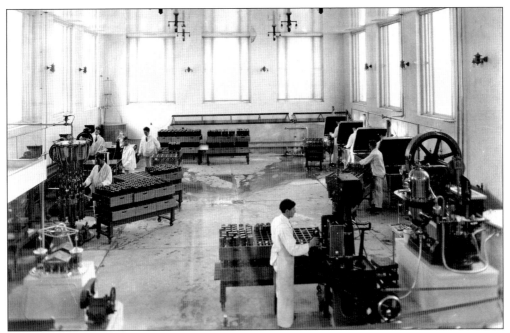

The water would come into the plant through glass and silver pipes that ran from the spring and would fill a cistern and large tank in the back. The bottles would then be rerinsed, filled, and capped and then sent individually on a conveyor belt to the warehouses. This is the view of the floor from the room where the public could sit and watch.

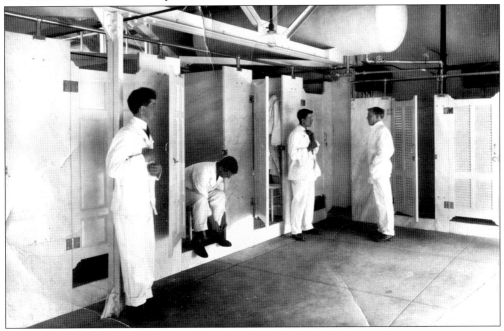

Each day the workers had to take a shower upon their arrival. The showers were on the second floor of the building and were fed by a several-hundred-gallon copper tank, which can be seen in the upper right-hand corner. The men then dressed in clean white linen uniforms prior to starting their shift on the plant floor.

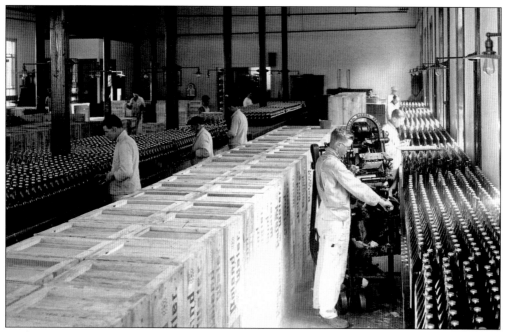

Within the two warehouses connected to the bottling plant, the workers would reinspect the bottles, label them, and then pack the bottles for shipment. The bottling workers could complete the entire process of sterilizing, rinsing, filling, capping, labeling, and preparing 450 cases of water for shipment during a 10-hour shift each day.

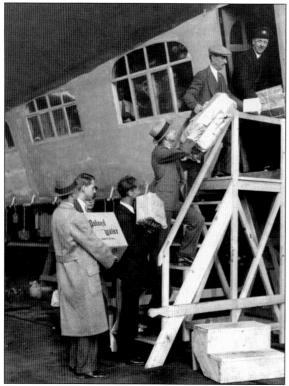

Poland Water was truly an international company and was served on transatlantic ships and even on zeppelins. Poland Spring contracted with the airship to provide water for its flights; the water was poured into aluminum containers to economize weight. This picture of the *Graf Zeppelin* being loaded was taken in 1929 at Lakehurst, New Jersey.

E. P. Ricker took a trip to the cork-producing factory in San Feliu de Guixol, Spain. Poland Water used corks to bottle water in the late 19th century until 1910, when it switched to metal caps, which were manufactured in the United States. Here E. P. stands with the owner of the factory, Senor Brugada.

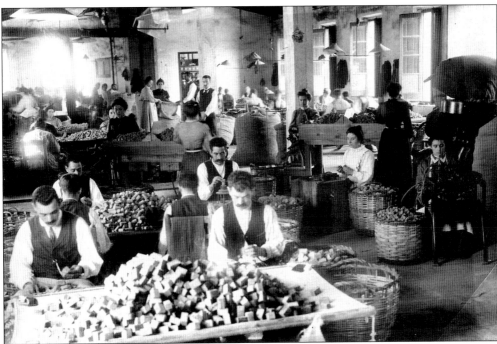

Cork comes from the bark of cork oak trees, which is harvested from a mature tree every 9–12 years, dried, and then cut into usable sizes. Here workers at the Brugada factory sort through the piles of cork and ready them for shipment to companies throughout the world.

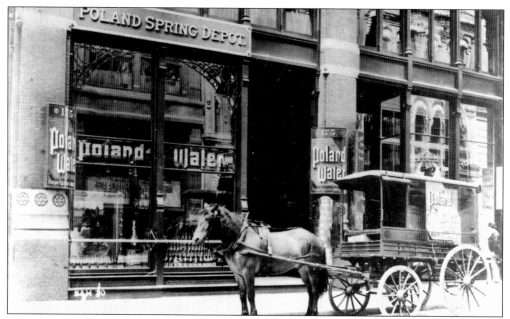

Poland Water had depot offices in New York, Philadelphia, and Chicago and this one at 175 Devonshire Street in Boston. Not only would they serve as ordering and shipping centers for water in urban areas but they would also market the resort as a tourist destination. The use of these offices would later help to position the family as one of the leaders of the tourism industry in the state.

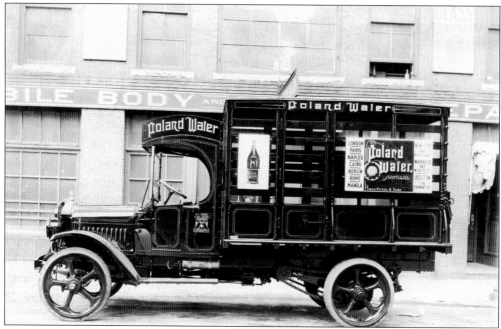

Eventually horse-drawn wagons were replaced with automobiles like this Mack truck seen in Boston. The depot stations continued to deliver the water in crates or five-gallon glass carboys as a means to get their products into homes and offices. While Poland Water's service area stretched across the country and the globe, the water continued to be bottled back home in Maine.

Four

THE MAINE STATE BUILDING AND CHAPEL

The Maine State Building and All Souls Chapel, both listed on the National Register of Historic Places, were two of the unique attributes that the resort used to attract guests. At the time of their building, it was believed that the resort was the first to have these types of buildings with the purposes of containing a library and art gallery and with a chapel that held Catholic and Protestant services.

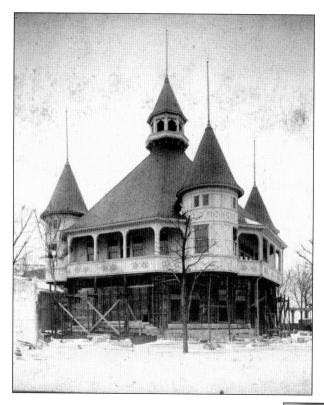

The Maine State Building was designed by Charles Sumner Frost, a Maine native living in Chicago. The Maine state legislature appropriated the money to construct the building to be sent to the 1893 World's Columbian Exposition in Chicago. It was constructed of materials from Maine, including granite from 10 different quarries, maple floors, oak woodwork, and a slate roof, all crafted by Maine workers. (Libby collection.)

Charles Sumner Frost was employed with Peabody and Stearns of Boston before moving to Chicago to begin working with Henry Ives Cobb. Frost designed the Maine State Building as an octagonal because of the irregular-shaped lot that it was to be placed on. In his later years, Frost designed the Navy Pier in Chicago as well as several other historic buildings in Maine and Illinois.

The building's dedication held on Maine Day on May 24, 1893, was conducted by Maine governor Henry B. Cleaves. Some of the prominent Maine natives who performed and spoke to the assembly included famed opera singer Lillian "Madame" Nordica, celebrated harpist Harriet Shaw, and Georgia Cayvan, who was a star of the American stage. (Libby collection.)

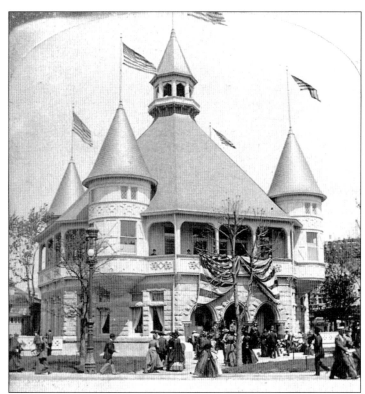

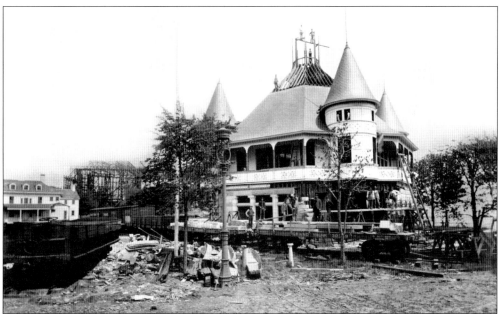

After the close of the fair, the state originally offered to leave the building to the city of Chicago to serve as an example of the fine craftsmanship and plentiful resources of the state. When the city declined, the building went up for sale and the Ricker family purchased it for $30,000. In 1894, Hiram Weston Ricker went to the grounds to oversee its removal and transportation to Poland Spring.

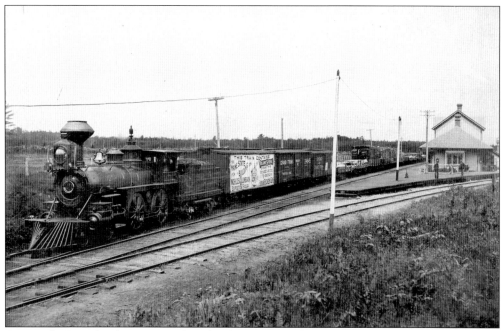

A special 16-car freight train was hired to bring the building from Chicago to Maine. Always mindful of marketing, the company made wise use of the train as a sort of publicity opportunity. Within a few years Poland Water was served on Pullman cars across the country. The train took a little over three days to bring it from Chicago to Maine.

The resort's head carpenter, Forrest Walker (1857–1932) oversaw many of the renovations that were made at the resort. In 1894, he and Hiram Weston Ricker brought a crew of men to Chicago to dismantle the Maine State Building for its removal to Poland Spring. Walker's systematic ability to mark and catalog all the pieces helped to carefully and successfully reconstruct it on the grounds.

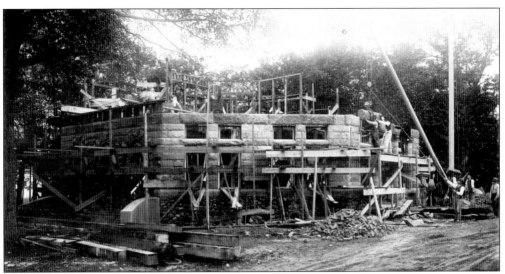

Led by Forrest Walker and under the watchful eye of Hiram Weston Ricker, the building was reconstructed on the grounds and readied in less than a year for its rededication. Several changes were made to Charles Sumner Frost's original design. The third floor was finished off for use as an art gallery, dormers and sky lights were added to the roof, and the front doors were replaced with beautiful carved oak doors.

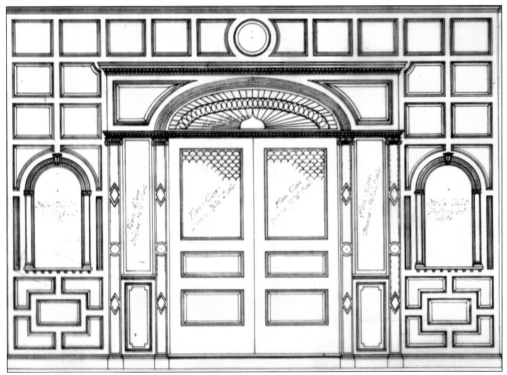

This architectural drawing by George Coombs is of the front doors created for the Maine State Building upon its reconstruction at Poland Spring. Mounted on either side of the doors were slate tablets that detailed the origins and purpose of the building and that it was erected on the grounds to commemorate 100 years of the Ricker family arrival on the property.

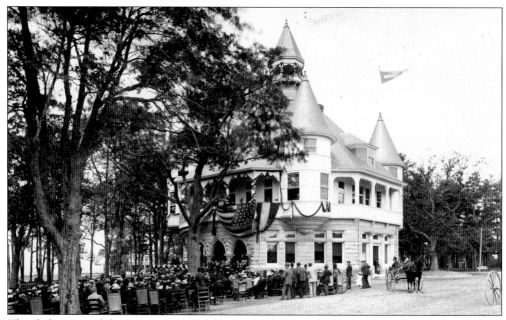

The dedication of the Maine State Building on July 1, 1895, was to celebrate 100 years of the Ricker settlement in Poland and was held in conjunction with the town's centennial celebration. State and federal officials from Maine and Massachusetts spoke at this ceremony, which was attended by local dignitaries, resort guests, and even members of the Shaker community. A large banquet and musical performance complemented the event. (Robbins collection.)

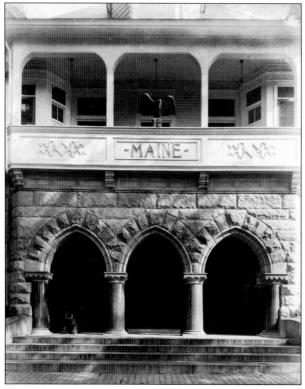

The cannon on the steps was given in 1898 by Mr. and Mrs. Dan C. Nugent, frequent guests of the resort. Seized in Manila in the Philippines at the close of the Spanish-American War, it became a beloved artifact because it had been cast and dedicated to the city in 1794, the same year Jabez Ricker settled the property.

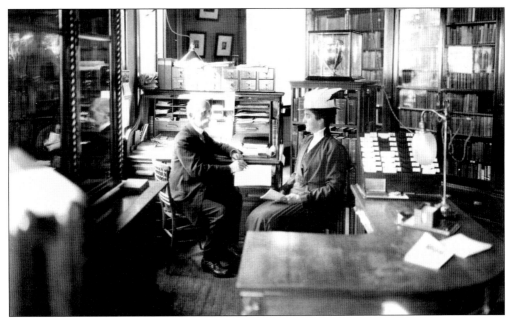

Frank Carlos Griffith (1851–1939) served as the head librarian in the Maine State Building for almost 30 years from its opening in 1895. Griffith also served in the capacity of coeditor of the resort's newsletter the *Hill-Top*. He was also well known in the theatrical profession and wrote several books and short stories. Griffith is pictured with Nettie Ricker in the office of the Maine State Building.

The *Hill-Top* newsletter began in 1894 and was issued until 1930. The weekly magazine was filled with details about what guests had checked in, the cars they drove, golf scores, lists of places to visit, local advertisers, bulletins on new renovations, and a host of other tidbits. It was originally the creation of two entrepreneurial resort employees, and Frank Carlos Griffith and Nettie Ricker coedited the newsletter for many years beginning in 1895.

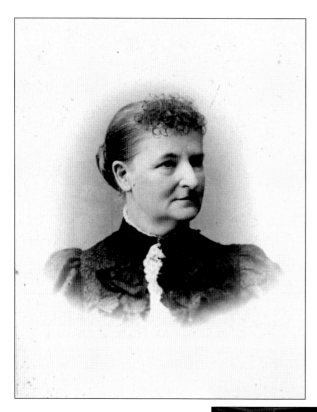

Catherine (Kate) Furbish (1834–1931) was a self-taught botanist and painter who was a frequent visitor to the resort and a friend of Nettie Ricker. Furbish gathered an extensive collection of flora and fauna found in the town, and this collection packed one of the exhibit rooms in the Maine State Building. A large collection of work documenting plant life throughout the state is at Bowdoin College in Brunswick where she lived.

Carved of oak by the Morse and Company of Bangor, one of the main focal points of the reading room was the remarkable mantelpiece and fireplace. Inset is a carving of the state seal, and above is a moose head donated by the premier of New Brunswick. To correlate with the origins of the building, dozens of photographs of buildings at the World's Columbian Exposition were hung in the rotunda.

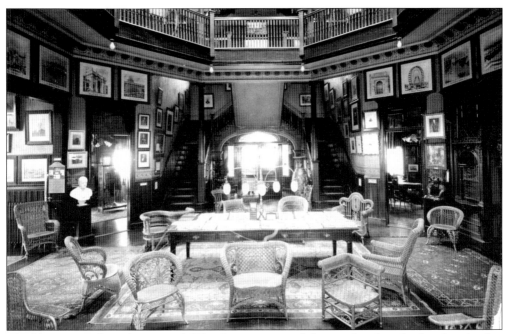

The library grew from the original 175 volumes to several thousand within the first decade after the dedication of the building. Resort guests and even authors themselves donated volume after volume of their favorite works for inclusion in the stacks. Newspapers and other periodicals were also available for guests to read. At its apex, the library had almost 10,000 volumes.

After decades of receiving many well-known and distinguished guests, pictures of presidents, governors, and military figures were displayed along the stairway. The bronze plaque at the right was given to the family in memorial of Hiram Weston Ricker by Rotarians from New Hampshire. At the foot of the stairs stands a Japanese satsuma vase that graced the building when it was in Chicago.

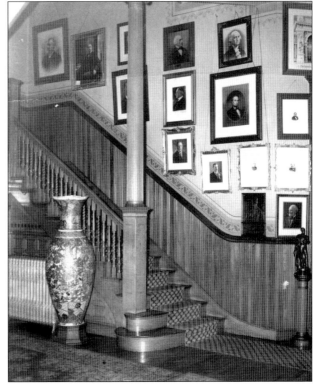

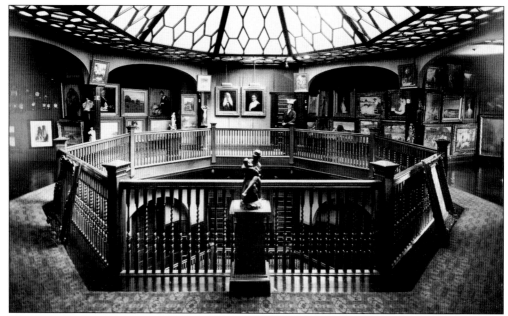

The art gallery on the third floor was under the direction of Nettie Ricker. For several decades, the gallery was praised for its ability to attract some of the great contemporary artists of the day. Artists who exhibited included Dana Delbert (D. D.) Coombs, Leon Dabo, Robert Vonnoh, Scott Leighton, and Harrison Bird Brown. Nettie Ricker is standing along the far wall near the portraits of her parents.

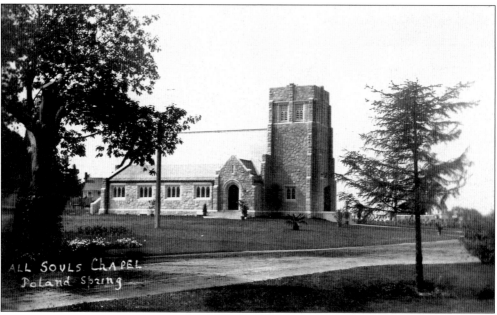

The chapel, completed in 1912, was designed by Boston architect G. Henri Desmond. He combined elements of Norman and Gothic architecture and presented the plans as a gift to the Rickers. Desmond designed several other unique buildings in Maine, including the Fidelity Trust Building in Portland, which was the first skyscraper in the state, and directed the renovation and expansion of the Maine State Capitol in Augusta from 1909 to 1911.

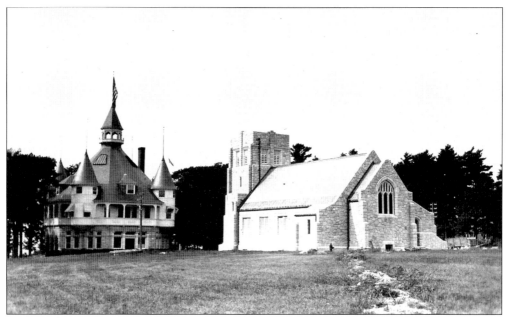

Prior to the construction of the chapel, services were held in the Poland Spring House and were led by headwaiter Juluis Gassauer. The staff encouraged the building of the chapel since many were Catholic and there was not a local cathedral. Funds were raised through fairs and donations by guests and the family. This picture was taken between 1912 and 1914.

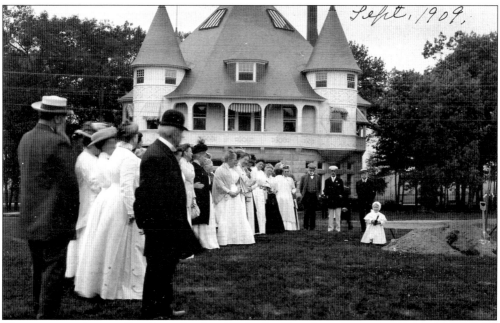

The ceremonial groundbreaking for the All Souls Chapel was held in September 1909 and performed by Garret A. Hobart III, grandson of Garret A. Hobart, the first vice president under Pres. William McKinley. Members of the Hobart family, who were from Paterson, New Jersey, were longtime guests of the resort and had even brought the first automobile to the grounds. (Chipman collection.)

The religious conviction of Sadie Ricker, seen at the far left, gave her the ambition for starting a Sunday school on the grounds for the benefit of the area children. She helped organize many of the fund-raising events and for three decades served as superintendent of the program. Sonny Chipman is the young man on the bottom steps with coat and tie standing with Sadie Ricker. (Chipman collection.)

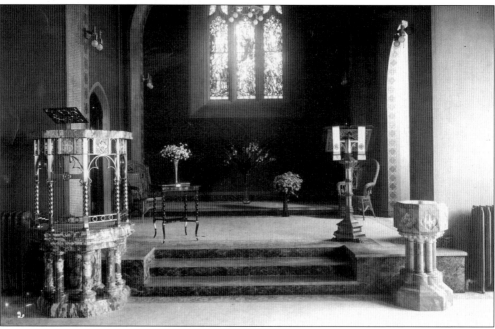

This picture of the chapel shows an early view of the interior. Many of the furnishings like the tables, chairs, and even the cross and baptismal font were donated by guests of the resort. Eventually an organ fund would be established, and in 1926, an Ernest M. Skinner pipe organ would be installed in the alcove at the right.

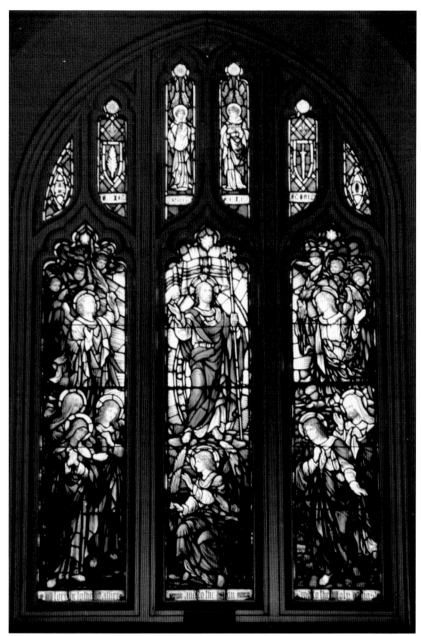

This beautiful window at the front alcove of the chapel depicts the resurrection of Jesus and was donated by two sisters from Philadelphia who were longtime guests of the resort. This exquisite window along with seven memorial windows was sponsored by various resort guests mainly from the Northeast. These memorial windows replaced the original stained-glass windows that were installed when the chapel was constructed. Each of the windows depicts various accounts from the Bible like the story of the Good Samaritan, and they are extraordinary examples of hand-painted glass. There are no records that seem to indicate who the artist or manufacturers of the windows were. The windows were complemented by the beautiful murals painted by the L. Haberstroh and Son Company of Boston. Haberstroh was also responsible for the many painted murals and other wall decorations throughout the Poland Spring House. (Guptill collection.)

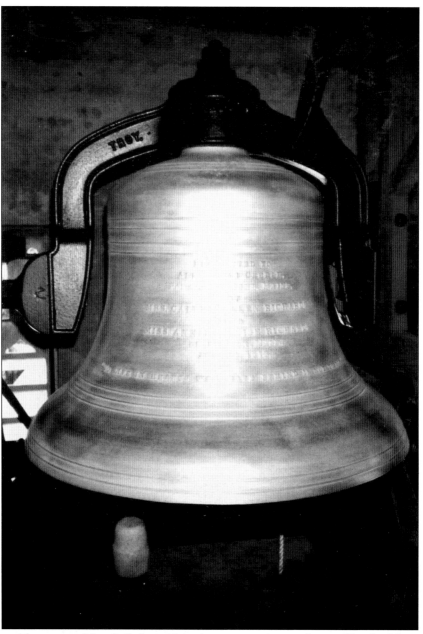

The chapel has a set of four bells housed in the tower and manufactured by the Meneely Bell Company of Troy, New York. Sometimes referred to as "Westminster Peals" or "Cambridge Quarters," the bells are made of Lake Superior copper and imported tin and are of the keys of G, C, D, and E and weigh 1,500, 500, 400, and 300 pounds, respectively. The four-bell set was donated by Mrs. Calvin Allen Richards and Annie Louise Richards of Boston. When the bells were positioned in the chapel, a special telephone was installed so that a call could be placed to Mrs. Richards so she could hear their first peels. The bells were rung for the first time by future president Calvin Coolidge, who would stay at the resort several times. Coolidge as vice president happened to visit Poland Spring the month before assuming the presidency when Pres. Warren G. Harding died.

The first wedding at the chapel was held on August 6, 1913, with the first baptismal immediately following. As the years progressed, many members of the Ricker family were baptized, married, or had their memorial services in the chapel. This picture is of Janette Ricker's wedding to Clarence "Pop" Houston on June 25, 1919. Janette was the daughter of A. B. and Cora Ricker.

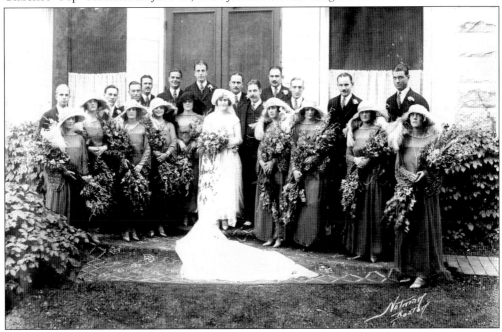

Here the wedding party of Edward "Ted" Payson Ricker Jr. and Elizabeth Miller Ricker, who were married on September 6, 1922, stands in front of the Maine State Building. Ted is the tall man in front of the doors, and his brother James Wesley Ricker is the gentleman to the right of the bride. Both of the buildings continue to have a dual role in weddings held at the resort.

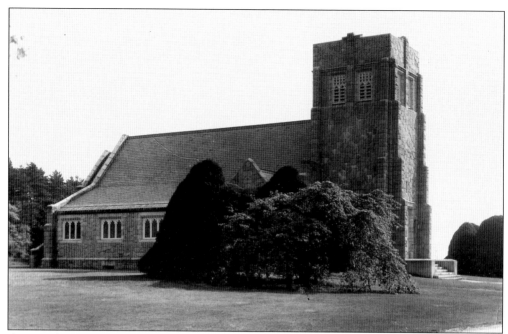

Among the most notable features of the chapel exterior are the two trees that adorn either side as one faces the building. The Camperdown elms (*Ulmus glabra* "Camperdownii") are Victorian in flavor and can be found on college campuses and older parks and neighborhoods throughout northern areas of the country.

Behind the chapel was a series of flower gardens that were an extension of the conservatory adjacent to the chapel. One of the gardens under the watch of A. B. Ricker, the flowers were raised to be placed in the dining halls of the hotels and were also available for sale at the Poland Spring House.

Five

Playing On and Off the Grounds

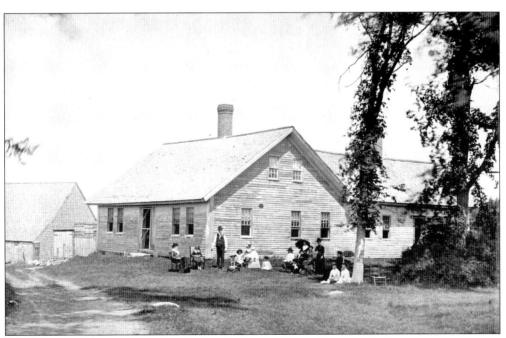

Hiram Ricker, seen here standing before the Brown Place, felt compelled to purchase as many of the adjacent properties as he could. It is said that he wanted to overlook his property and to not be able to see any of his neighbors. The Brown Place was traditionally used as housing for employees and was located near the ponds.

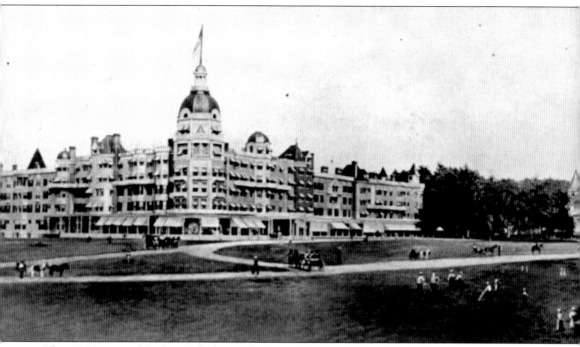

This 1904 view of Ricker Hill shows, from left to right, the newly renovated Poland Spring House, Maine State Building, the Hiram Weston Ricker cottage, the resort gatehouse, Mansion House, the newly constructed general store, livery stables, and the Brackett House, which boarded employees. There were a remarkable number of renovations and new construction that took place in the latter part of the 19th century, and the pace would continue as the resort

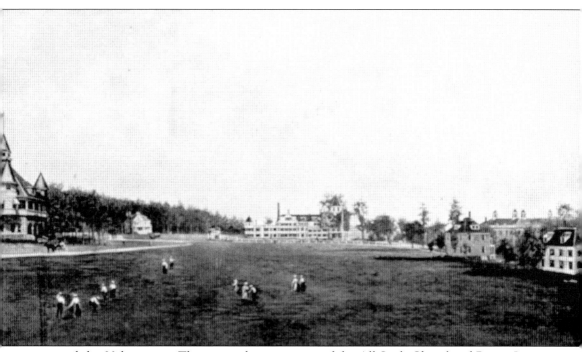

entered the 20th century. The eventual construction of the All Souls Chapel and Riccar Inn, changes in the golf course, and the addition of the caddy camp building shortly afterward would dramatically alter this view. Aside from the demise of the Brackett House, the crest of Ricker Hill would remain relatively unchanged until the construction of the Executive Inn in 1963 by Saul Feldman. (Robbins collection.)

In the center is the springhouse for the Wampole Spring Company that sat across from the resort property. It is said that the Ricker family would tell people not to drink the water because it flowed through their cemetery. The structure in the grove of trees is the old schoolhouse, and at the right next to the cemetery is the Ricker schoolhouse. (Chipman collection.)

The Ricker cemetery, seen at the right, was the final resting place for family members beginning with Jabez Ricker. The one exception seems to be Robert Cheever, who was a Confederate veteran. Cheever came to Poland Spring to take of the waters and died while staying at the resort in 1878. A stone for Cheever was placed in the cemetery by the Confederate Memorial Society of St. Louis.

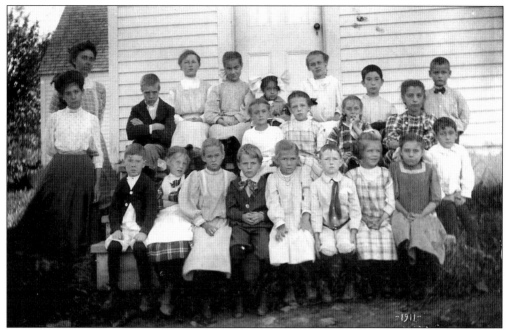

This was the second schoolhouse on the grounds in District No. 5 and was referred to as either the Ricker Brothers or Poland Spring schoolhouse. Many of the students who attended school here were children of resort staff, but many neighboring families also sent their children here. This is a picture of schoolchildren from 1911.

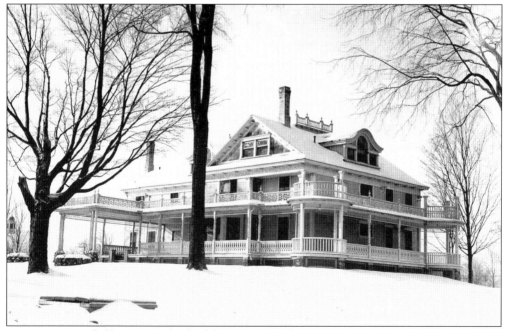

Known as Campbell Cottage, this building was owned by one of the investors in the Wampole Spring Water Company. Eventually purchased by the Rickers in the early 1900s, the building was used by longtime distinguished resort guests and also by family members. In the 1920s, Elizabeth Ricker would have a dog kennel for her sled dogs at the house.

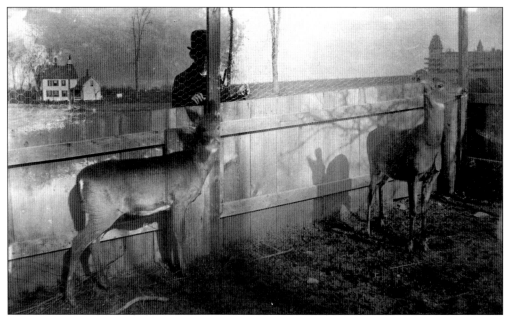

To satisfy the curiosity of urban "city" folk, during the late 19th century the resort installed a fenced-in area called the deer park on the grounds near the Mansion House. This pen held several deer, and with the surrounding farm pastures and naturally occurring animals on the property guests had an opportunity to be as close to nature as they preferred.

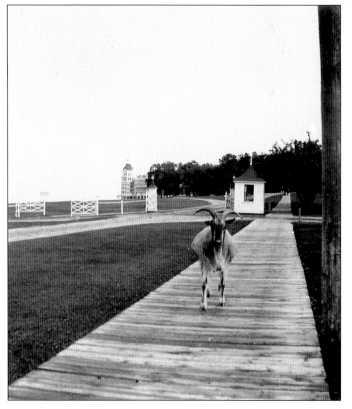

Sandy was a goat who was in a way a mascot of the resort during the first part of the 20th century. He, like other animals on the property, was beloved, much photographed, and even sat for a sculptor. When he died, his head was mounted in the lobby of the Mansion House. Here he is walking down the boardwalk by the main gatehouse toward the Mansion House. (Robbins collection.)

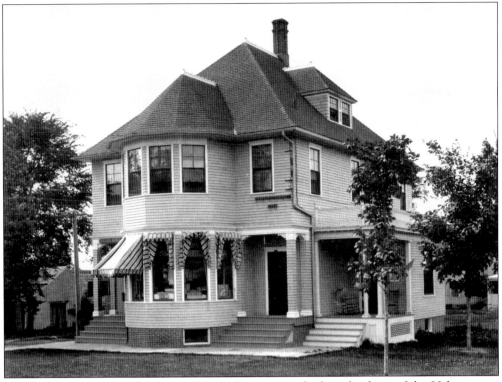

This building, sometimes known as Canary Cottage, was built at the dawn of the 20th century. Its original purpose was to serve as a general store and gift shop, offices for the Ricker sons, and the exchange for the Poland Telephone Company. It is now known as Roosevelt Cottage and is used as guest housing at the resort.

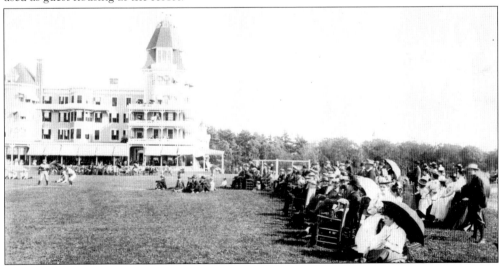

Baseball was a popular spectator sport at Poland Spring. Louis Sockalexis, a member of the Penobscot Nation, played baseball for the resort team and eventually for the Cleveland Spiders (later the Cleveland Indians). He hit .338 in 66 games in 1897 but ended up injuring an ankle when he jumped from a window. He is regarded by many to be the first Native American to play major-league baseball.

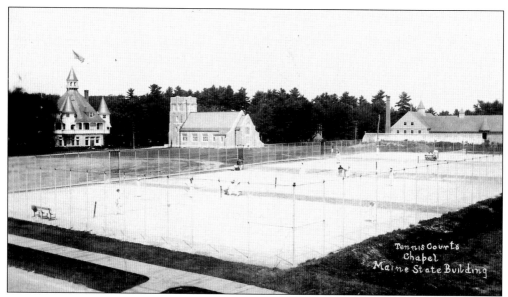

Guests of all ages enjoyed playing tennis or participating in a game of lawn bowling. Located on the lawn between the chapel and the Hiram Weston Ricker cottage, the courts played host to many annual singles and doubles tournaments and served as another competitive recreational activity for guests to compete in.

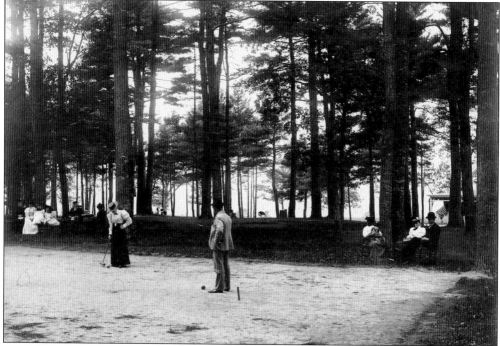

Croquet was more popular with women and children, especially when the golf course opened, but was certainly not exclusive to them. Other recreational activities that were pursued during the late 19th century included bicycling and even walking and running. All these physical activities were part of the health and wellness philosophy that brought the middle and upper class to the resort.

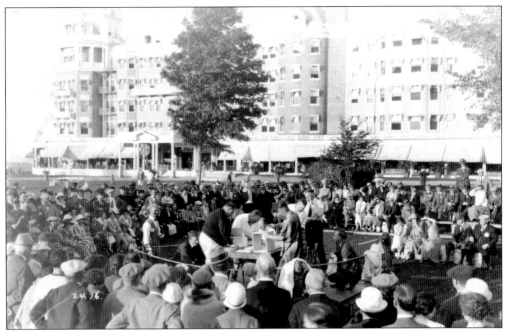

Opportunities for playful competition and spectatorship were a benefit to the social life of the resort. In this picture in what appears to be a play on words, two competitors build boxes in front of the Poland Spring House inside a boxing ring with referees, managers, and plenty of spectators looking on.

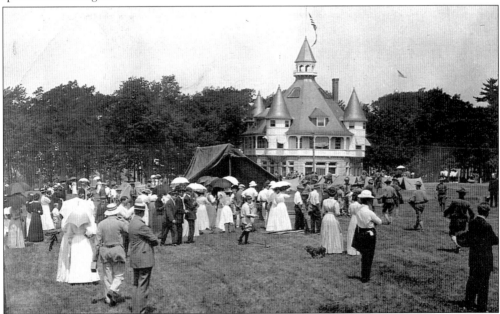

This picture from 1909 depicts Companies K and L of the United States Infantry from Camp Plattsburgh in New York making camp on the lawn across from the Maine State Building. They marched from New York to Maine to help train Maine's militia on the methods and tactics of the regular army. They conducted several exercises during their stay, including a mock battle for the enjoyment of the guests.

Members of the Penobscot Nation from Old Town would come to Poland Spring in the summertime to sell their wares. Originally their camp was across the road from the golf course next to the livery stables, but when the Riccar Inn was built they moved to the woods across from the springhouse. The resort routinely suggested that its guests should visit their tents to buy sweetgrass baskets and other souvenirs.

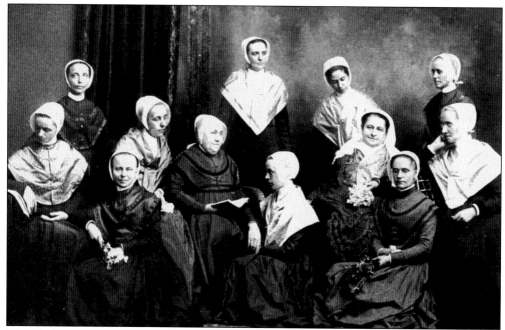

The Shakers were invited to sell goods on the grounds and in the Poland Spring House. This picture taken at the resort studio is of members from the New Gloucester and Canterbury communities. Sr. Aurelia Mace (holding book) was a frequent visitor to the resort grounds and was praised at the dedication of the Maine State Building.

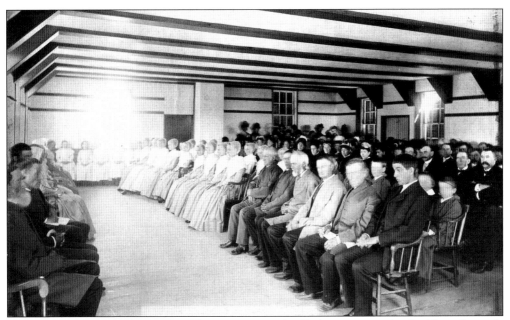

Resort guests also traveled to New Gloucester to see the Shaker property that had been formerly settled in 1794. Members of the public were allowed to attend certain Shaker meetings like this one held in 1880. The religious order formed in Manchester, England, in 1747 had three communities in Maine, one in Alfred, one in Gorham, and the Sabbathday Lake community in New Gloucester.

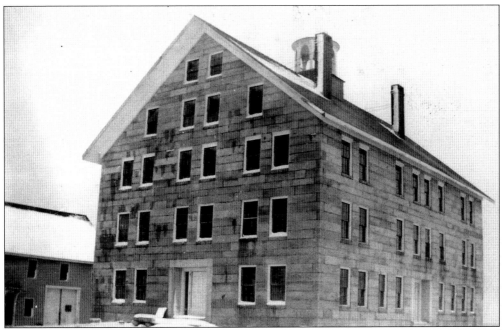

In 1899, the resort purchased the buildings of the Poland Hill Shaker family, which was a part of the Sabbathday Lake community. The buildings, like the stone house here, were used for storage and in support of the resort's agricultural needs. The buildings burned in the 1950s after being struck by lightning, and all that remains on the property is a cemetery. (Robbins collection.)

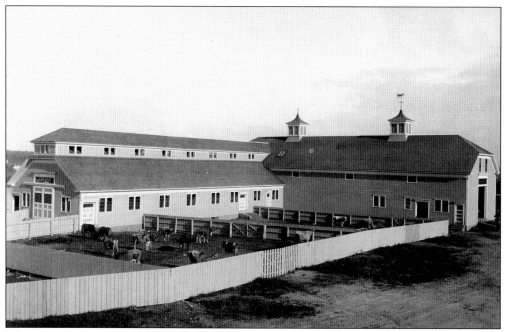

The farms were an important part of the resort business. A. B. Ricker was known as a shrewd buyer of goods that found their way to the dinner table, but a great deal of the produce and meat came from the farms that were owned and operated by the resort. This cow and hay barn on the lower part of the grounds was close to Middle Range Pond.

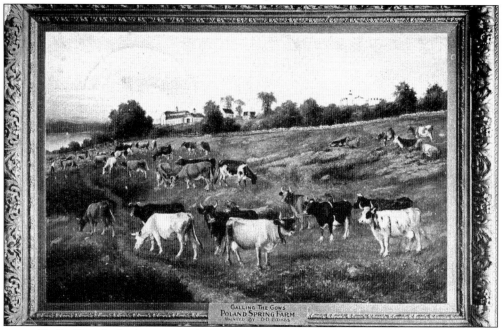

Artist D. D. Coombs had a passion for animals, and many of his paintings had cows as their subject. This painting titled *Calling the Cows* shows the cow and hay barns to the left and the Poland Spring House at the right. At times the resort might have had over 100 head of cattle in the farm pasture, almost 100 hogs, and scores of chickens and turkeys.

Poland Spring Livery.

JUNE 25, 1892.

LIVERY PRICES.	1 Hour.	2 Hours.	3 Hours.	4 Hours.	5 Hours.
Single Team	2.00	2.50	3.00	3.50	4.00
Double 3 Seats	3.50	5.00	6.00	6.50	7.50
Five Seats with Two Horses	5.00	6.00	7.00	8.50	10.00
Five Seats with Four Horses	7.00	8.50	10.00	12.50	15.00
Eight Seats with Four Horses	8.00	10.00	13.00	15.00	18.00
Landau with Four Horses	8.00	10.00	13.00	15.00	18.00

REMARKS·—We make our charges on even hours. The occupant of the carriage is entitled to thirty minutes over time without any extra charge, but for over thirty minutes the full hour will be charged.

All expenses of team when out driving will be added to the above price.

No Five Seated Vehicle let without a driver.

Price will be made up from the time the team leaves the stable until it returns.

Any parties wanting team all day will be subject to the five hour price only, and for that price they are entitled to drive a distance of twenty-five miles.

All former price lists prior to this date are void.

Yours respectfully,

HIRAM RICKER & SONS.

Guests who did not bring their own horses could hire a horse or maybe a driver and carriage. These were opportunities for guests to visit other parts of the region, visit the Shaker community, go to Lewiston or Auburn, or take a riding tour around one of the local lakes or up an area mountain.

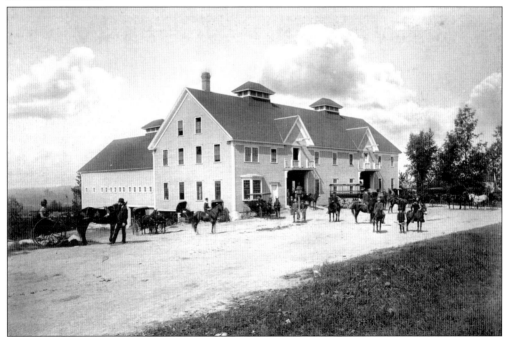

The main livery stables were across the road from the Mansion House. In 1887, the building was greatly expanded from its original construction in 1825. The stables were destroyed by fire on August 21, 1894, and replaced the following year. The second livery stable structure was destroyed by fire in 1984 along with the former caddy camp building, which was located nearby.

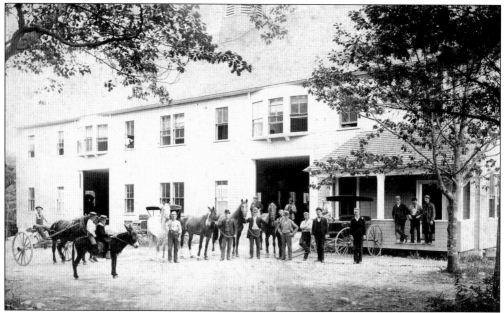

This guest stable was built in the 1890s to accommodate horses and carriages for those staying at the resort and was located near the Poland Spring House adjacent to the future site of the chapel. The section to the right was later removed from the building and relocated adjacent to the livery stables across the street from the golf course for use as the caddy camp house. (Chipman collection.)

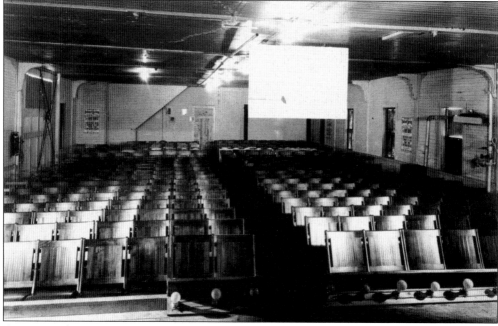

A summer theater was eventually installed in the former guest stables and showed movies and offered a place for performances by resort staff and members of the caddy camp. The entire upper stables were destroyed by fire, and a gymnasium was located in its place when the Job Corps program was at Poland Spring from 1966 to 1969.

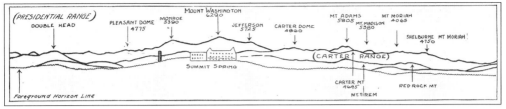

From atop Ricker Hill, which is at an elevation of almost 800 feet above sea level, an individual could see almost dozens of mountain peaks from the verandas and tower of the Poland Spring House. The most impressive view is of the Presidential Range, which includes Mount Washington, New Hampshire's tallest peak.

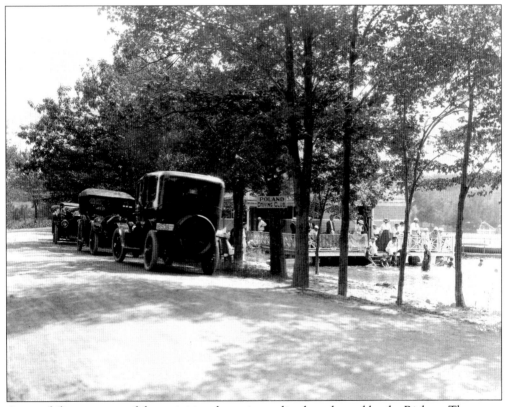

Automobiling was one of the activities almost immediately embraced by the Rickers. The resort purchased several 12-passenger mountain Stanley Steamers for touring. Hiram Weston Ricker was one of the founders of the Maine Automobile Association, which touted the automobile and better roads as means to encourage tourism throughout the state. Hiram's son Charles W. Ricker Sr. would follow in his footsteps as a member of the association's board.

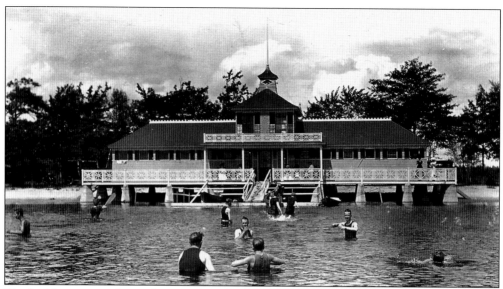

The bathhouse served as a changing area for guests and also had a social area on the top floor for men to play cards and chat. Originally erected on piers in the water, in the 1930s it was set back onto land. In the mid-1980s, it was transformed into residential space and continues to be a part of the resort property.

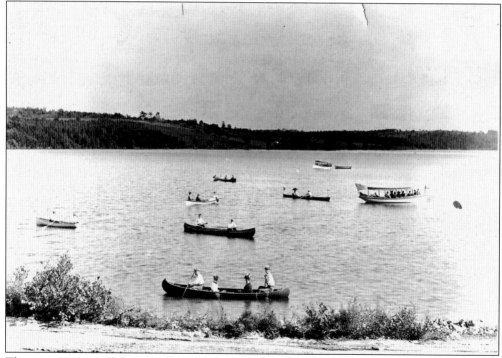

The resort promoted the use of the Range ponds as a recreational opportunity for its guests. The resort had its own steam launch, the *Poland*, and Hale's boatyard provided opportunities for guests to take a canoe or sailboat for a leisurely cruise or to fish on the ponds. In the early 20th century, the resort lightheartedly referred to the ponds as Lake Edward, Lake Alvan, and Lake Hiram.

This icehouse at Middle Range Pond and located adjacent to Hale's Boathouse was one of several owned by the resort. Ice was harvested from the ponds and stored here throughout the summer months for use. In 1909, for example, over 20 tons of ice was used each week for refrigeration and for food preparation. (Robbins collection.)

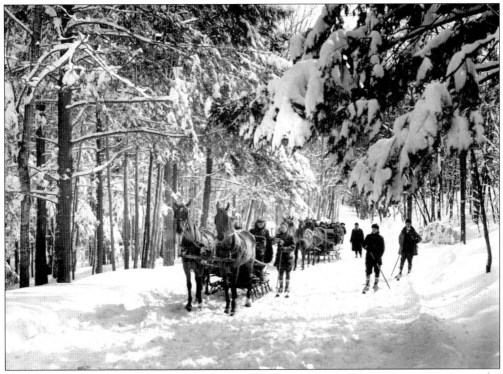

Wintertime brought a new sense of excitement and activity to the woods around the resort. Winter guests like these in the late 1800s would have stayed at the Mansion House. As the Rickers continued to market themselves as a winter recreational resort they would draw on connections to Maine and New England as being the Switzerland of the Americas.

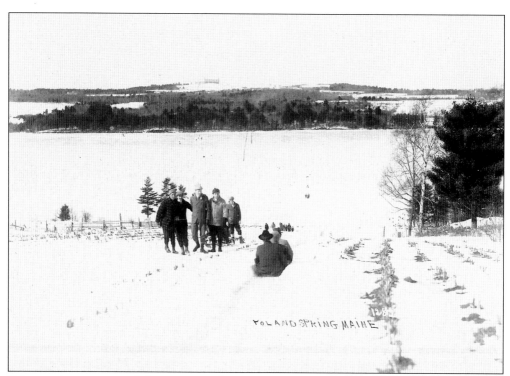

Tobogganing was one of the most popular winter activities at the resort. With half a dozen individuals on the toboggan, they would travel down the 1,500-foot chute and had enough momentum to shoot three-quarters of a mile across the lake. The least fun of course would be hiking back to the top since there was no one employed to pull the sleds back to the top.

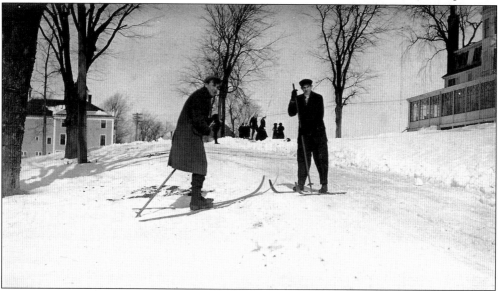

This picture from February 1909 shows George A. Ricker Sr. and Charles W. Ricker Sr. skiing on the resort grounds with the livery behind them to the left and the Mansion House at the right. This is one of the earliest known dated photographs of skiing or "Norwegian snowshoeing" that was taken in Maine.

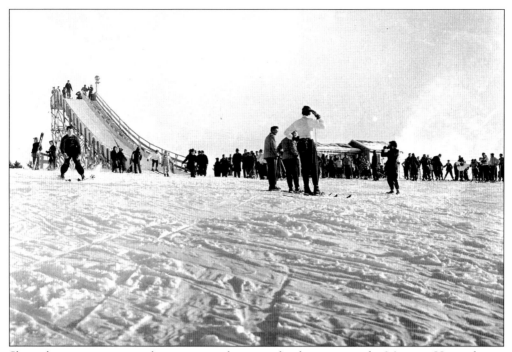

Skiing became a very popular recreational activity for the guests at the Mansion House during the winter. By the 1920s, the toboggan run had been complemented by a ski tow and a large ski trestle was built for the guests and even local community members to use. This view of the slope is from 1947. (Chipman collection.)

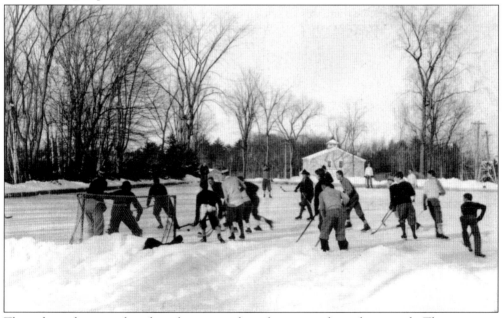

Throughout the years there have been several ice-skating ponds on the grounds. This main one behind the Riccar Inn served as a place for ice-skating for the guests but also for playing hockey. The ownership cheerfully acknowledged that the rinks were flooded nightly in order to maintain the glare ice.

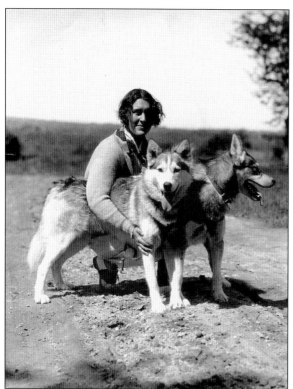

Elizabeth Ricker, wife of Edward "Ted" Ricker Jr., was a well-known sled dog musher. She befriended Leonard Seppala, the famous driver of the sled team that delivered the diphtheria serum to Nome, Alaska, in 1925. Eventually she was given Togo, the lead dog for much of the treacherous journey. In the 1920s, Elizabeth helped attract several sled dog races to the area using the resort as the base.

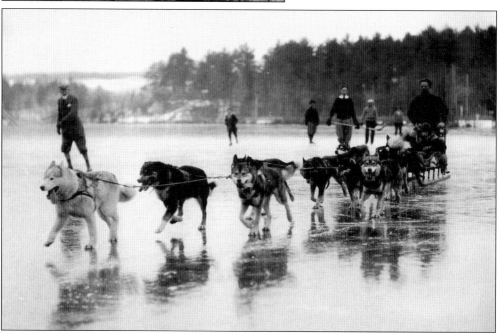

This picture from the late 1920s shows Leonard Seppala driving his sled on one of the Range ponds. Seppala and his dogs were quite an attraction for guests staying at the resort. In order to recoup some of the costs of transportation, Seppala allowed individuals to take rides for a small fee.

Six

THE LINKS AT
POLAND SPRING

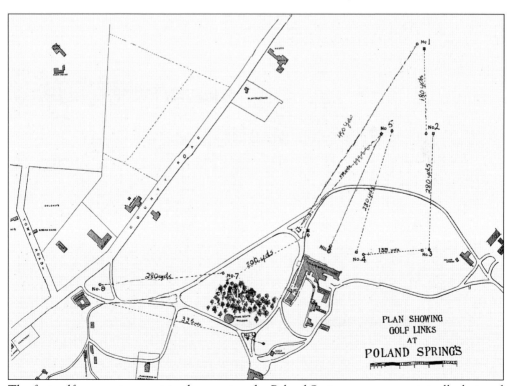

The first golf course at a resort in the country, the Poland Spring course was originally designed as a nine-hole course. The links, designed by Arthur H. Fenn, were opened on July 30, 1896. Fenn set the first course record with a 47, which he then lowered by two strokes the following day.

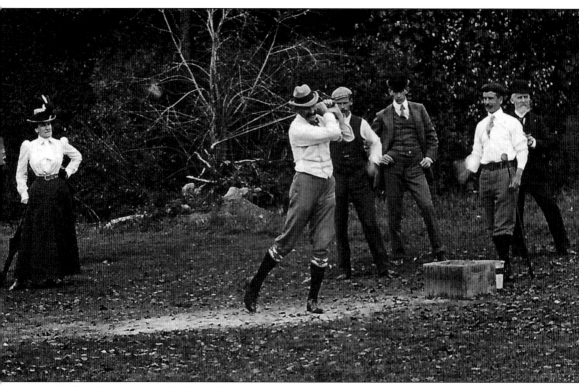

Arthur Harris Fenn (1857–1925) was known as a superb athlete and had only taken up golf a couple of years prior to being hired to design the course at Poland Spring. He eventually stayed on to work as the professional and lived adjacent to the resort while also maintaining a wintertime position at Palm Beach. Fenn designed several other courses including one in his hometown of Waterbury, Connecticut, and is known as one of the first American born professional golfers. He captured the prestigious Lenox Cup three years in a row from 1895 to 1897, and in 1918 won the first Maine Open. After his death in 1925, his daughter Bessie succeeded her father at Poland Spring for the summer and permanently in Palm Beach and is considered to be the first women professional to be in charge of a club in the United States. Arthur Fenn was inducted into the Maine Golf Hall of Fame in its inaugural year in 1993. Fenn is the golfer in the center.

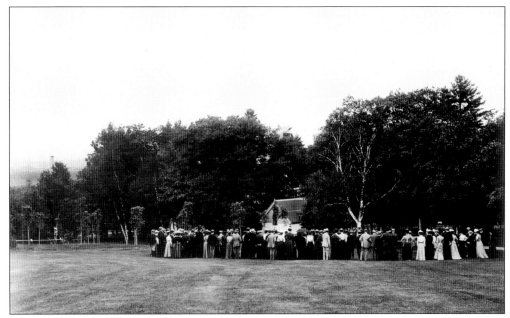

Golf was very much a spectator sport at Poland Spring and immediately attracted a following. It was still relatively a new sport in the Americas, and many guests became extremely fascinated by the grace of the golfers and the competitive opportunities it served. This picture taken in 1900 is of a crowd gathered around the third hole. The original springhouse can be seen in the background.

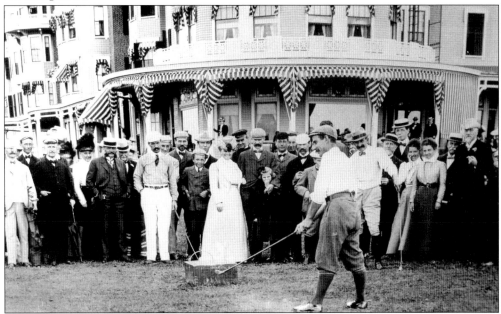

In 1900, Harry Vardon, the winner of an unmatched six British Opens, toured throughout North America. He played at Poland Spring against Arthur Fenn several times winning by a few strokes each time. Fenn also paired with Alex Findlay, another golf pioneer, and beat Vardon in a best ball contest. Findlay is at the left in white pants, Vardon is about to tee off, and Fenn is in the back.

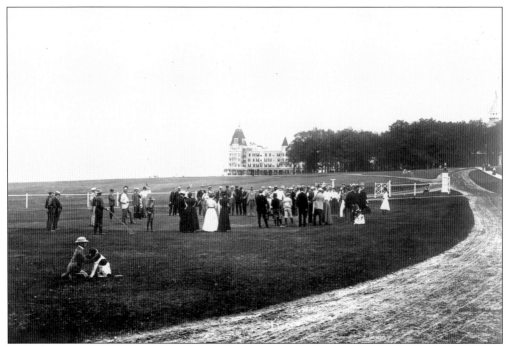

This shot of the former eighth hole of the original course was played in front of the Mansion House. Since the tee for the ninth hole was in front of the Mansion House, it was common practice for guests to start the course from the ninth and finish off the course at the eighth hole.

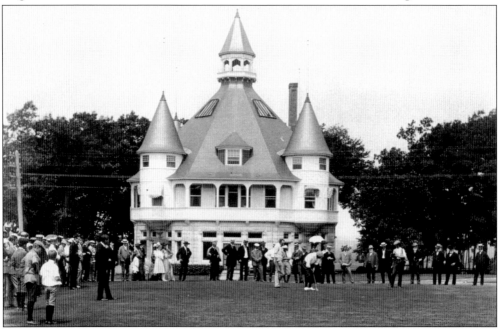

The ninth hole of the original Arthur Fenn golf course lay adjacent to the Maine State Building. Seen here is Fenn playing on the course as a gallery watches. Fenn's daughter Bessie who would fill in for him after his death in 1925 and also served as an assistant librarian at the Maine State Building in the 1920s.

The venerable Scottish-born golf architect Donald Ross of Pinehurst No. 2 fame redesigned the Fenn course, which opened in 1915, and added nine holes. Ross designed almost a dozen courses in Maine, with the course at Poland Spring being his oldest in the state. Fellow World Golf Hall of Fame member Walter J. Travis had a hand in the 18-hole course's layout as well.

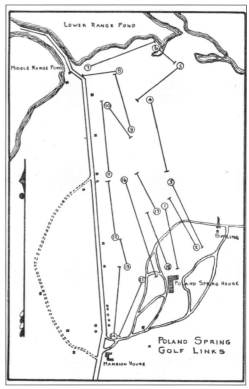

The signature hole of the golf course, the fourth hole is symbolic of Donald Ross's ability to use the features of the land and the scenic beauty to his best abilities. Golfers would emerge onto the tee and find themselves looking downhill through a narrow vista with forest on both sides, overlooking Lower Range Pond.

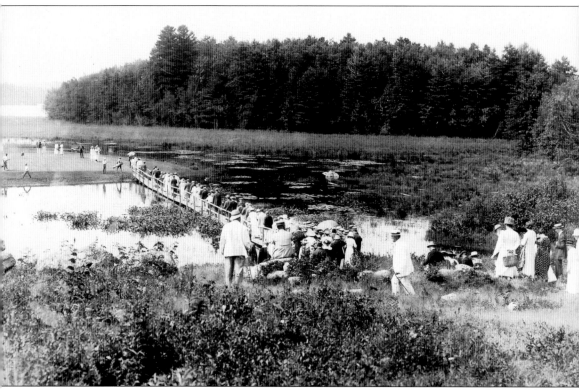

This photograph is of the Red Cross Golf match held a Poland Spring in the summer of 1918. These matches, held during World War I, were a huge attraction around the country as a fund-raiser for the war effort. A foursome of well-known young golfers, Perry Adair, a 16-year old sensation by the name of Bobby Jones, national women's champion Alexa Stirling, and former western champion Elaine Rosenthal traveled throughout the country in support of this effort. This picture shows some of the 200 spectators of the match crossing the bridge on the sixth hole. The four-ball match with accompanying auction and other activities raised $5,777 for the Red Cross, one of the largest totals raised during the year. During the series of matches, Jones lowered the men's amateur record to 75, Rosenthal lowered the women's amateur to 86, and Arthur Fenn lowered the men's professional to 73, which would be lowered to 69 by Fenn in three years.

There were many golf contests, including putting tournaments, geared for both men and women. Many trophies sponsored by various guests were up for grabs, including individual championships like the Chick, Hobart, and Halsell Cups. These cups would stay on display at the Poland Spring House until someone captured the title three years in a row. A new cup named in honor and sponsored by that person would then be established.

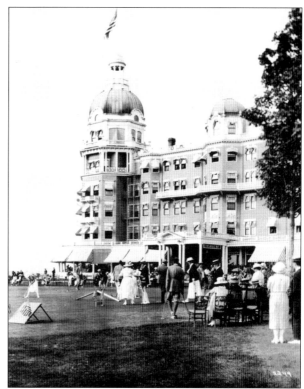

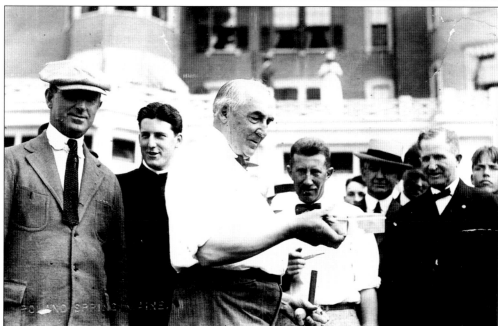

Pres. Warren G. Harding visited Poland Spring several times and would play golf each time. This picture from July 1921 shows the president receiving a cigar box as a gift from the Ricker family after playing a round. Sen. Frederick Hale of Maine is seen holding his pipe behind the president, and A. B. Ricker is seen at the left of the senator.

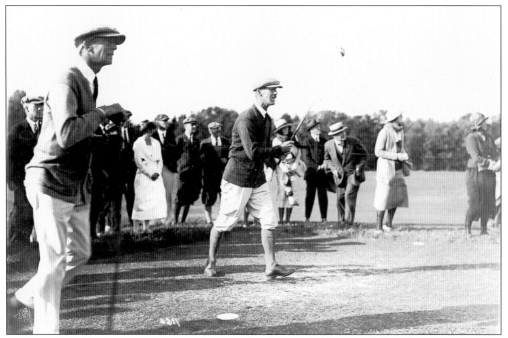

Other early golf superstars came to play at Poland Spring. Abe Mitchell and George Duncan came for an exhibition match in 1921. Duncan was the previous year's British Open winner, and Mitchell was regarded by many to be the longest driver of that era. The golfer on the Ryder Cup is in the likeness of Mitchell. Alex Chisholm, an early Maine golfing legend, stands at the left while Mitchell drives.

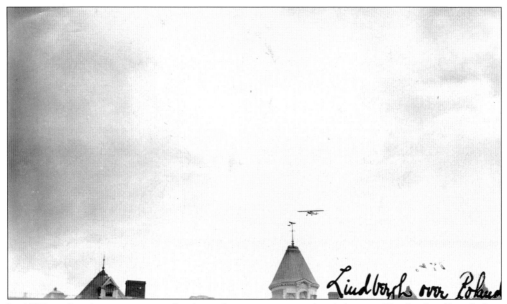

Lindbergh over Poland

In 1927, on his American tour after his solo voyage across the Atlantic, Charles Lindbergh flew to Poland Spring in order to visit his uncle John C. Lodge. Guests of the resort were so excited to see him that they crowded the fairway, and thus Lindbergh was unable to land. He scribbled a note to his uncle on a map and threw it overboard explaining his inability to land.

One of the most famous athletes of all time, Babe Ruth came to Poland Spring to play golf on several occasions. Here the "King of Swat" poses with Poland Spring golf professional Andy Gray in the mid-1940s. It is said that he was not necessarily the best golfer but gave really good tips to his caddy. (Chipman collection.)

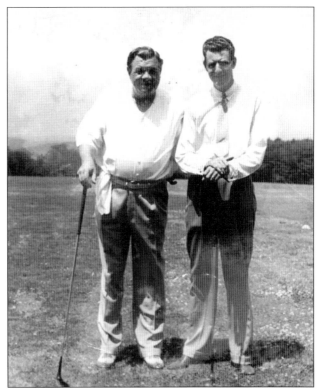

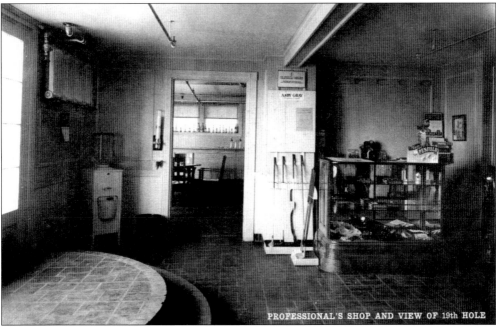

PROFESSIONAL'S SHOP AND VIEW OF 19th HOLE

The pro shop for the course was originally in the Poland Spring House. It remained there until the 1960s when the Job Corps came to Poland, returned after the program ended, and went homeless when the Poland Spring House burned in 1975. In 1976, a clubhouse was relocated from another part of the property and became the new pro shop.

From 1921 until 1965, Poland Spring operated a caddy camp on the grounds. Originally the camp provided underprivileged youth from the South End Settlement House in Boston an opportunity to earn money and become more disciplined. Numbering from 60 to 90, the participants were between the ages of 11 and 20 and lived in a building on the grounds across from the golf course.

Tom Turley became the director of the caddy program in 1926 and served for many years at Poland Spring. Turley also lived next to the South End Settlement House in Boston. His philosophy for the camp was that it was more than just an opportunity for youngsters to tote golfers' clubs; it was the ideal of making men. Turley is the gentleman seated left center.

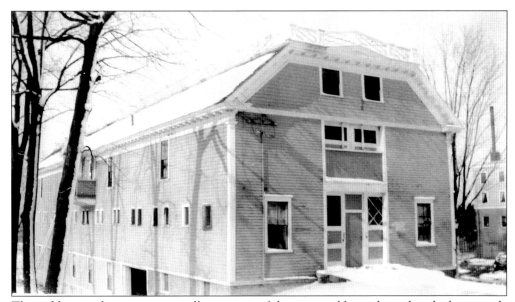

The caddy camp house was originally a section of the guest stables and was detached to provide housing for the caddies. The boys were literally living in old stables. The caddy master would wait for a call from the pro shop and would then send out a caddy, who would run up to the course.

Bob Hatch and Chick Leahey were the last two camp directors of the caddy program at Poland Spring. Both were World War II veterans and members of the Bates College athletic department and brought with them an understanding of how to work with the teenagers through tough discipline. The two also created new programming activities to encourage leadership and teamwork among the participants.

The caddies were divided into several teams for the season and played competitive sports during their time off from working on the course. Games included baseball, running, obstacle courses, and even boxing. Here, in a picture from 1957, two caddies engage in one of the friendly matches in the caddy camp house.

Here members of the caddy camp program gather to head down to one of the ponds to go swimming. Some of the more industrious caddies would "bag" or caddy twice in a day in order to make more money while others would take the afternoons off. Those who excelled in their duties and kept out of trouble would be given the distinction of being named an honor caddy.

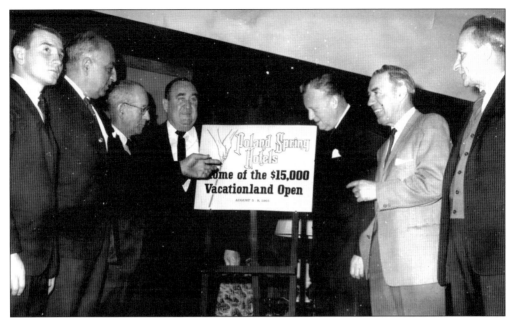

The last national tournament held at the Poland Spring golf course was the Vacationland Open with a $15,000 purse to the professional winner. PGA tour professional Bert Yancey of Miami, Florida, took top honors and was awarded the Ernest W. Newnham Memorial plaque. Newnham was the winner of six Maine Opens and was inducted alongside Arthur Fenn in the inaugural class of the Maine Golf Hall of Fame.

This picture of the participants of the last caddy camp program participants was taken in 1965. With the advent of golf carts and the impending arrival of the Job Corps in 1966, the camp was discontinued. Although many of the kids participating were not necessarily participants of the South End House program, most were from Boston and surrounding communities.

Tony DeRocco was a longtime member of the Poland Spring golf community and served as the superintendent and professional for several decades. He lived on the property adjacent to the resort and contributed greatly to the course's ability to return to its former glory. In 1994, Tony was inducted into the second class of the Maine Golf Hall of Fame. (Robbins collection.)

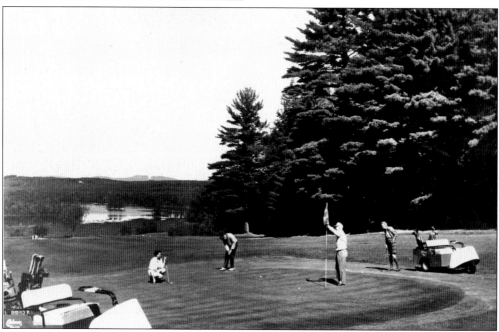

This shot of the 11th hole was taken in the late 1960s. As the years of the caddy came to a close, the new era of carts would begin. Interestingly enough, this postcard distributed by the resort is of William and Margaret Sievert, parents of future owner Cynthia (Cyndi) Robbins, several years before her tenure on the grounds would begin.

Seven

LIFE AFTER THE RICKERS

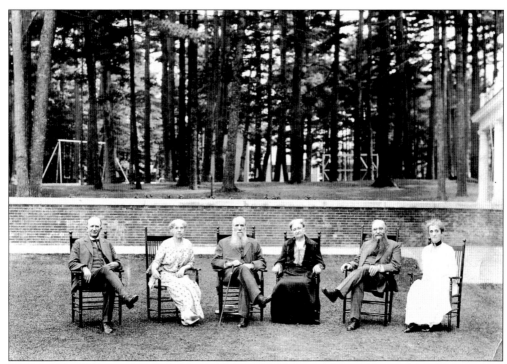

This picture of the six Ricker children was taken in 1926. From 1928 to 1933, the three brothers who had maintained ownership passed away, which caused an upheaval in the management of the hotel. This combined with the Depression, the changing tourism industry, and the heavy investments made by the Ricker Hotel Company led to the decline in the Ricker family's ability to maintain sole ownership of the business.

By 1938, Hiram Ricker and Sons had gone into receivership and reorganized with Fred Lancaster as president, Charles W. Ricker as vice-president, and George Lane as treasurer. This was the first in a series of partnerships that would own and operate the property over the next two decades. Other investors and owners in the property during the two decades included Clark-Babbitt Industries, which at the time had a substantial interest in the operation of the Howard Johnson Company, and Apollo Industries, which owned the property for less than a year. During this period the property was seen as a business venture and not something that would receive the commitment and attention it had under the Rickers. Charles Connor, on the right shaking hands with caddy Dave Brauer at the 1955 Caddy Camp dinner, took over as executive vice president in 1947. Connor would serve in several capacities including manager of the water company during his tenure at Poland Spring. Connor also oversaw the construction of the new inn when Saul Feldman purchased the property in 1962.

Although Hawaii was admitted as a state on August 21, 1959, the 50-star flag did not become official until July 4, 1960, in accordance with the law signed by Pres. Dwight D. Eisenhower. This picture taken on that day is of a 50-star flag being lowered after it had been raised above the Poland Spring House.

The same flag was immediately flown to Hawaii where it was received and raised at Hickam Air Force Base a short distance from Pearl Harbor. The flag was then brought to the statehouse in Honolulu where it was presented to Gov. William F. Quinn by U.S. Air Force master sergeant John J. Burke of Dover-Foxcroft seen at the far right.

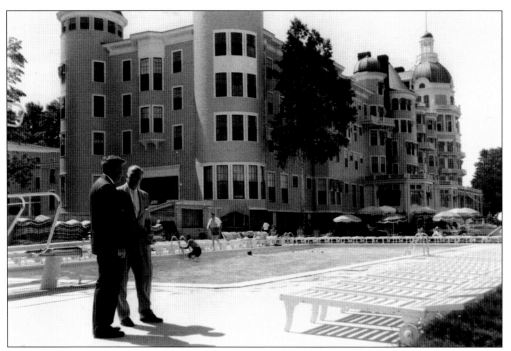

After two decades of ownership by various firms and corporations, the resort's future was in limbo. In 1962, Saul Feldman (1908–1990) purchased the resort and its 5,000 acres. One of his first goals was to rebuild the resort's image and update its offerings, which included the building of a new inn and expanding its recreational opportunities. Saul Feldman is the gentleman facing the camera.

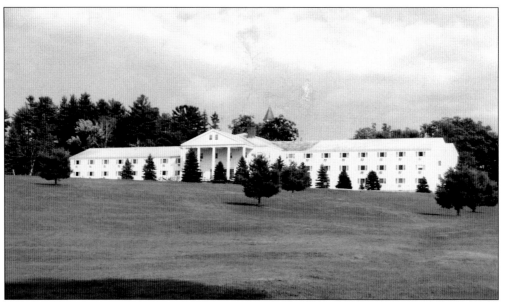

In 1963, the Executive Inn was opened with private bathrooms, telephones and television, and a number of other modern amenities. It continued to offer some of the other traditional services such as bellhops, numerous waitstaff, and caddies for the golf course. The inn is now known as the Maine Inn.

Saul Feldman sought to attract television, movie, and musical personalities as well as many local and national governmental officials to stay at the new Poland Spring resort. Here Feldman stands with former Maine governor, then United States senator and future secretary of state Edmund Muskie. (Feldman collection.)

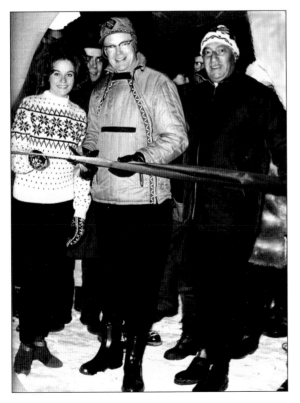

When Saul Feldman purchased the property, he wanted to build upon Poland Spring's reputation as a winter resort. Part of this was the building of a new ski slope on the back side of the grounds. The slope was opened in 1963 by Olympian Penny Pitou and frequent visitor Gov. John Reed. The slope, now part of a recreational trail system, was used until the 1970s by guests and students at area schools. (Feldman collection.)

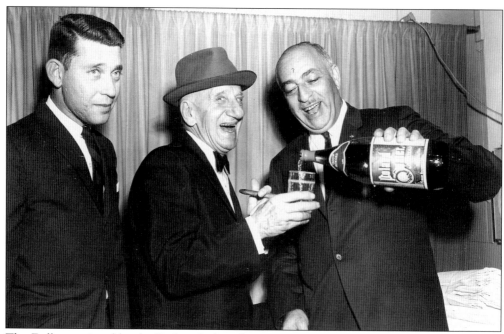

The Fedlmans, just like the Rickers before them, were quick to use prominent individuals as part of their marketing. Here Loren Feldman, Saul's son, and Saul pose with Jimmy Durante. Durante said that he was never too far from his old friend Poland Water and that it helped keep him young. (Feldman collection.)

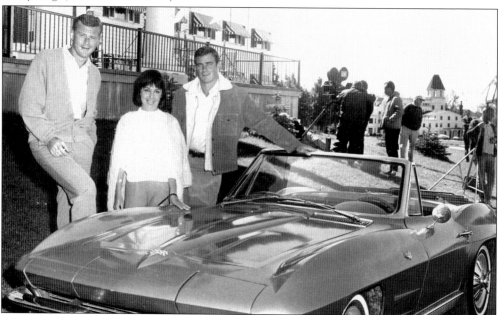

The television show *Route 66* filmed two episodes on the grounds of the resort in 1963. Here stars Martin Milner and Glenn Corbett stand with Tudi Feldman, Saul Feldman's daughter-in-law and hotel hostess, in front of the Executive Inn. The Mansion House can be seen in the background on the right. Joan Crawford and Lon Chaney Jr. were also involved in the taping of the show at Poland Spring. (Feldman collection.)

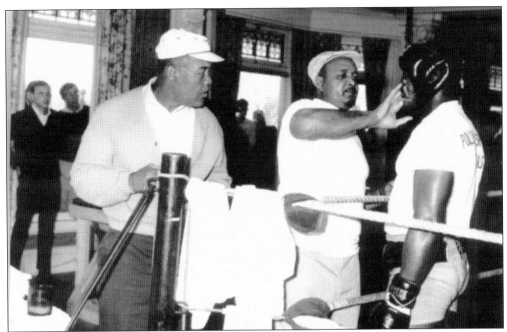

Sonny Liston fought Muhammad Ali (then known as Cassisus Clay) in a boxing match in 1964. When a second scheduled fight between the two was cancelled in Boston, the fight was moved and held in Lewiston in 1965. Liston, seen here training in the dining room of the Mansion House, is joined by Joe Louis and Liston's trainer. (Feldman collection.)

Jack Paar, here with Tudi Feldman, was host of the *Tonight Show* from 1957 to 1962 before Johnny Carson. In 1965, he bought the WMTW television station at Poland Spring that was housed in the basement of the Riccar Inn. Paar stayed at Poland Spring for only a few years, but the station remained in the building for several years after his departure. (Feldman collection.)

Job Corps Center For Women

Poland Spring, Maine

Be it known that

MARIA DELGADO

has satisfactorily completed the requirements set forth by this Center and is awarded this Diploma

in recognition of her accomplishments

Robert B. Lake
Center Director

John F. Nevins
Director of Education

Patricia E. Webb
Director of Living

Poland Spring was tapped to be the largest women's training center of the Job Corps, which opened in April 1966. The Job Corps was one of Pres. Lyndon Johnson's Great Society's War on Poverty programs introduced in 1964. The program's mission was to offer a free residential training program for young men and women from the ages of 16 through 21 who were without jobs and without the financial means or education to acquire a job. Positions that women were educated and trained to become included nursery aides, florists, stenographers, dental assistants, and veterinary assistants. While on the grounds, the women participated in a number of other areas including budgeting, cooking and sewing, and recreational and social activities, and used the Poland Spring House as the dormitory. This graduation certificate was earned by Maria Delgado, who graduated from the printing program in 1967. (Delgado collection.)

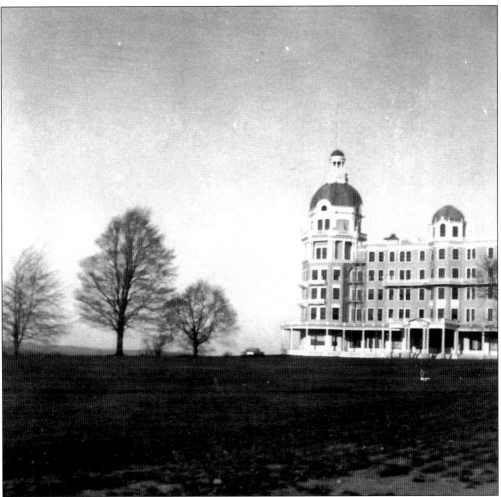

In the summer of 1970, Saul Feldman, looking to recoup some of the losses due to the early departure of the Job Corps, leased the resort buildings to the International Meditation Society. The Poland Spring House and other buildings were used to host the hundreds of individuals who came to the resort for a program on transcendental meditation headed by maharishi Mahesh Yogi. The maharishi had gained quite a bit of recognition just a few years before with his association with the Beatles. When the society left the grounds, there were disagreements over payments, and Feldman and the organization engaged in a series of legal battles that would last for several years. This would be the last time the Poland Spring House was to be used for housing as the old hotel was determined to be in too poor of condition and outdated to house resort guests.

Melvin (Mel) Robbins (1927–2007) came to Poland Spring to develop the 5,000 acres. He had little formal education and worked in a variety of jobs, and by the late 1960s, he had found success in land development. In 1972, Robbins convinced Saul Feldman that he could save Poland Spring with residential land development. Feldman would only give Robbins an option if he agreed to operate the Maine Inn also. Knowing nothing about the hotel business, in the first year, Robbins lost all his money operating the resort as it had been with bellboys, hordes of waitresses, and other extravagant services. But a strange thing happened, Robbins heard the "rustle of petticoats," fell in love with the property, and decided to make Poland Spring his home. To save the hotel, Robbins got rid of all the unnecessary services and began to cater to the budget-minded. Throughout his time at Poland Spring he served as innkeeper and an all-around entertainer for his guests. Robbins also wrote several books and plays and was known for his letters to the editor. (Robbins collection.)

Cynthia (Cyndi) Sievert came to Poland Spring to work for the resort in 1971 after moving to the area with her parents. She worked for Saul Feldman as a waitress, and when Mel Robbins arrived, she began to work for him. In 1975, in the dining room of the Poland Spring House, Mel asked Cyndi to marry him. Consequently, in a matter of just a few years, she went from waitress to food and beverage manager to chef and co-innkeeper. On July 12, 1982, after leasing the property for a decade, Mel and Cyndi purchased the resort and golf course from Feldman and continued to invest in the buildings and their upkeep. However, they never forgot it was the staff "with their minds, and hands, and hearts who helped rebuild Poland Spring." They continued to successfully market the property as a budget resort while remaining customer-oriented—a philosophy that continues. When Mel's health was in decline, Cyndi took over the operations of the resort and continues the legacy that they built. (Robbins collection.)

After a decade of owning the entire Poland Spring property, Saul Feldman sold the water side of the business to Perrier of France in the early 1970s when it was nearly bankrupt and employed only a handful of individuals. After only a few years, Belgian-born Paul den Haene purchased Poland Spring Water from Perrier. Den Haene, who began his career in the beverage industry in France, brought some new ideas to operate the company. He found additional sources about 1,000 yards from the original source and built a new larger and modern facility. Through aggressive marketing and utilizing the history of the brand, den Haene began to increase Poland Spring's share in water sales in the United States. In 1980, Perrier repurchased Poland Spring from den Haene. Perrier was later acquired by what is now known as Nestle Waters North America. (NWNA collection.)

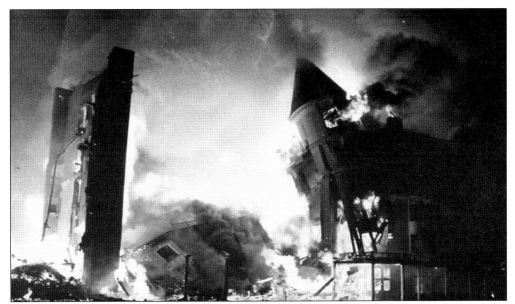

The Poland Spring House had been closed for five years after years of neglect and was in poor condition. When the Robbinses took over operations at the Executive Inn, Saul Feldman ran the golf course out of the Poland Spring House. On July 3, 1975, a fire broke out at the grand hotel, and within a short time the entire structure was engulfed in flames.

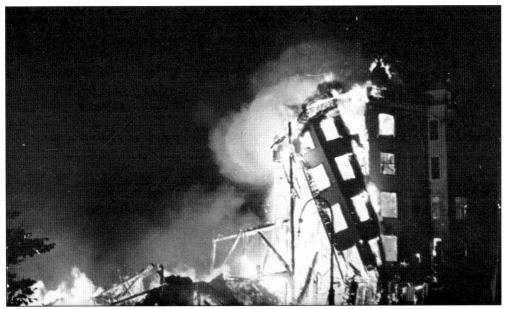

Although fire crews from all over the region arrived in a timely fashion, the building could not be saved. Hundreds of local citizens gathered on the golf course to watch the hotel fall victim to the flames. While it is uncertain as to the true cause of the fire, the lack of insurance on the building kept the structure from being rebuilt.

James (Jim) Aikman (1943–1978) was the news director for WMTW-8, which was housed in the Riccar Inn. He was very intrigued by the stately buildings on the grounds, and following the destruction of the Poland Spring House in 1975, he began the Poland Spring Preservation Society with the intent of preserving the rich heritage of the place. In 1977, Aikman convinced Saul Feldman to give the Maine State Building and All Souls Chapel to the society in order to preserve and maintain them for future generations. Tragically, Aikman was killed in a car accident and was subsequently honored by the historic preservation community in the state for his dedication to saving these important cultural treasures. Aikman is seen at the left standing in the rotunda of the Maine State Building with Bernett F. Kennedy Jr., who was the first member of the society.

The Poland Spring Preservation Society immediately set its goal on restoring the grand buildings and began to showcase the building's beautiful architecture as well as share the Poland Spring story with visitors through their museum collections and programs. Here Marion Emery, longtime member of the board of directors, greets visitors to the Maine State Building at its centennial celebration in 1995.

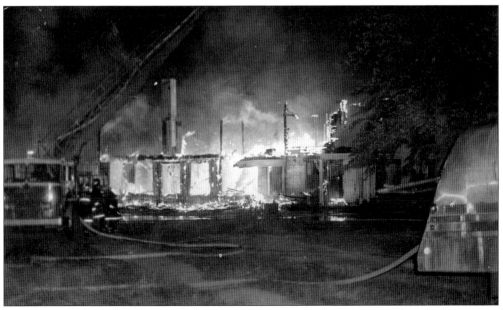

In 1977, after it was determined that the cost of updating and renovating the Mansion House would be too costly, Saul Feldman sold the rights to the building to a local resident who planned to salvage the wood. The building sat partially demolished for two years, and in 1979, a mysterious fire broke out and consumed most of what was left of the building. (MacDonald collection.)

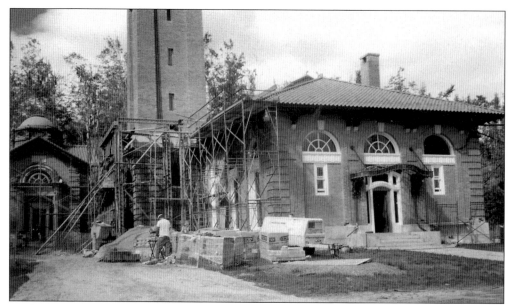

By the late 1990s, the Ricker-built bottling facility and springhouse had fallen into disrepair due to vandalism and neglect. Nestle Waters North America, which owned Poland Spring Water, funded the restoration of the buildings, which were listed on the National Register of Historic Places. In 2002, the buildings reopened as a museum and environmental education center with a recreational and nature trail system. (NWNA collection.)

By the 1970s, the bathhouse that was originally opened on Middle Range Pond in 1909 was in a sad state. Mel and Cyndi Robbins, mindful of an opportunity to preserve history, renovated the building and transformed it into living space. The structure was added to the National Register of Historic Places in 1999 and is now known as the Beach House. (Robbins collection.)

Poland Spring is a resort and a water company, but most importantly it is a community that has played host to a number of visitors from every corner of the globe. Since 1794, weary travelers, foreign dignitaries, presidents, governors, heroes, socialites, and the average person have brought themselves to its hallowed grounds in search of tranquility and relaxation. The owners, staff, visitors, and times have changed, but they add to the history and charm of the community. Nard Leckler, a guest and poet, wrote in 1930, "There is no scene but beckons to the eye, with brimming wealth and matchless charm, while overhead the blue unclouded sky, dispense peace and healing balm . . . In this fair spot there stands a lofty grove, inviting all who yearn from rest, a boon to man, a precious treasure-trove, its balm a riddle still un-guessed. A spring there is with water fresh and pure, where yet again lurks mystery, that Heaven blessed this bit of Earth is sure, God's gift to all posterity."

BIBLIOGRAPHY

Bennett, Mary E., ed. *Poland: Past and Present 1795-1970*. Poland Anniversary Committee, July 1970.

Leckler, Nard. *The Charm of Poland Spring and Other Poems*. New York, NY: 1930.

Richards, David L. *Poland Spring: A Tale of the Gilded Ages, 1860-1900*. Durham, NH: University of New Hampshire Press, 2005.

About the
Poland Spring
Preservation Society

The Poland Spring Preservation Society is a 501(c)3 nonprofit formed in 1976 by individuals concerned for the future of the Maine State Building and All Souls Chapel, which were both listed on the National Register of Historic Places. The Maine State Building was the state's pavilion at the World's Columbian Exposition, held in 1893 in Chicago, and is made of Maine granite, timber, and slate and is a fine example of the Queen Anne style of architecture. The All Souls Chapel was built in 1912 as an interdenominational chapel for use by the guests and staff of the Poland Spring Resort and combines elements of both Norman and Gothic architecture.

The society also strives to preserve and share the rich heritage of the Poland Spring region through its archival and museum collection and publications like this one, organizes low-cost community-oriented activities, and provides free educational programming to schoolchildren throughout the state. It is able to accomplish these tasks under the direction of its board of directors, staff, countless volunteers, and supporters and friends.

For more information about the organization, its programming efforts, or Poland Spring history, please visit the society's Web site. Or better yet, come to Poland Spring and take a tour of the fine historic buildings and gain an appreciation for their architectural beauty.

ACROSS AMERICA, PEOPLE ARE DISCOVERING SOMETHING WONDERFUL. *THEIR HERITAGE.*

Arcadia Publishing is the leading local history publisher in the United States. With more than 3,000 titles in print and hundreds of new titles released every year, Arcadia has extensive specialized experience chronicling the history of communities and celebrating America's hidden stories, bringing to life the people, places, and events from the past. To discover the history of other communities across the nation, please visit:

www.arcadiapublishing.com

Customized search tools allow you to find regional history books about the town where you grew up, the cities where your friends and family live, the town where your parents met, or even that retirement spot you've been dreaming about.